ROBERT DODGE
VIETNAM 40 YEARS LATER

DAMIANI

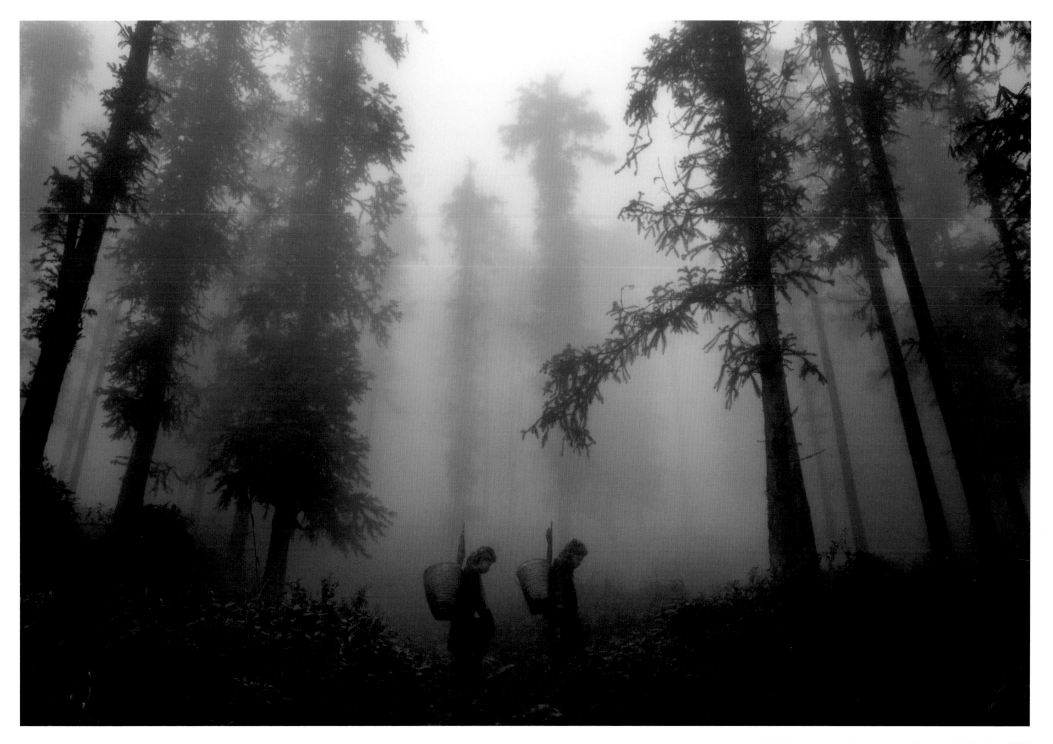

Red Dao women heading to market, Sapa, Lao Cai Province, 2010

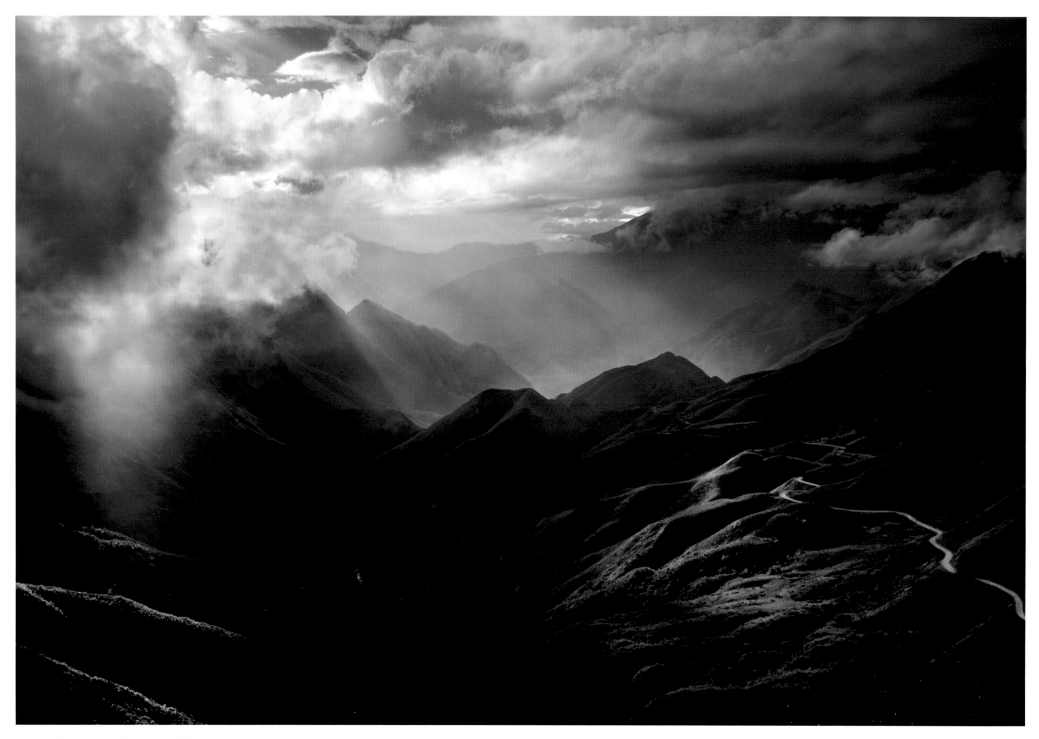

Tram Ton Pass, Sapa, Lao Cai Province, 2010

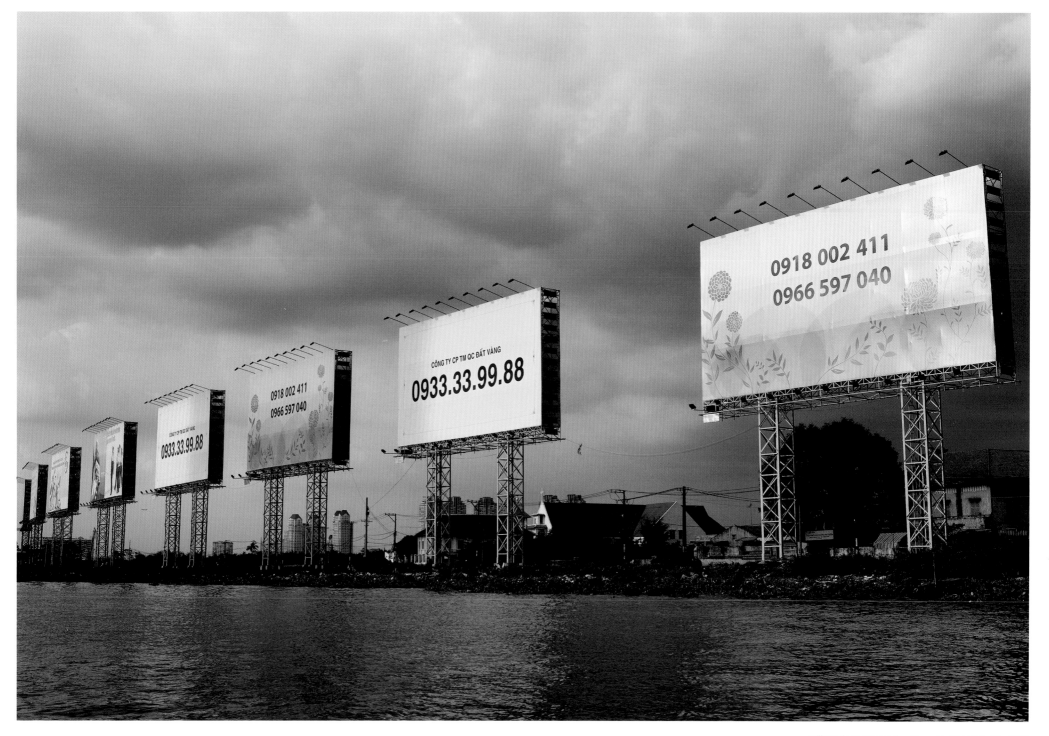

Billboards awaiting advertisers, Ho Chi Minh City, 2013

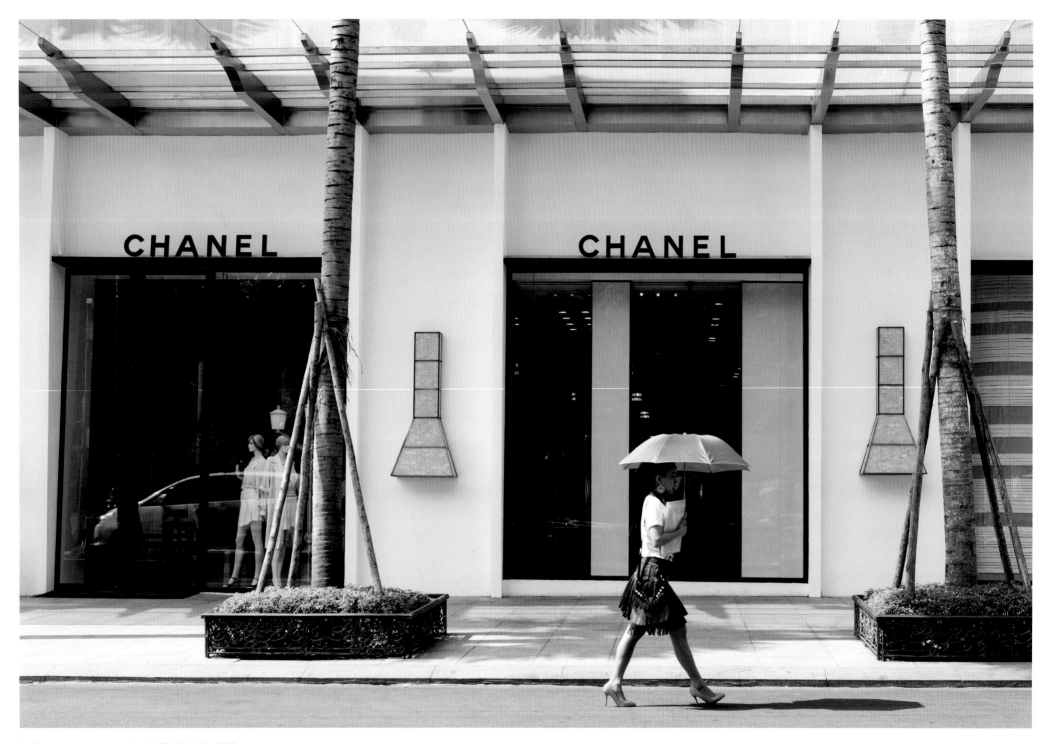

Fashion conscious commuter, Ho Chi Minh City, 2012

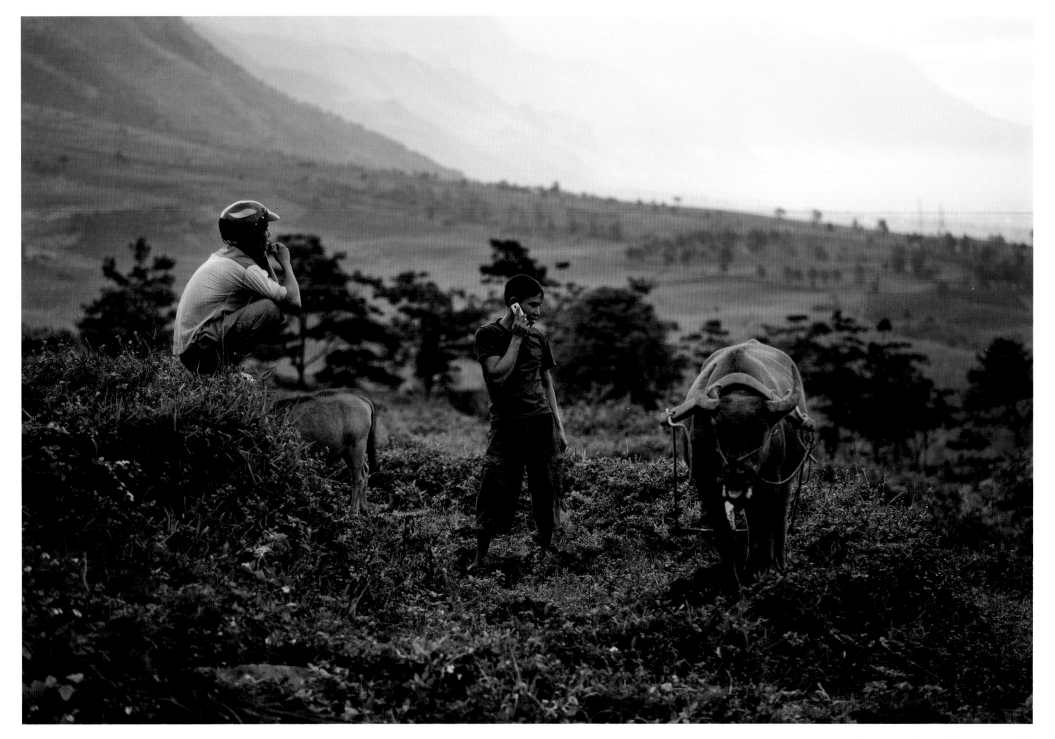

Rice farmer on cell phone, Lai Chau, Lai Chau Province, 2013

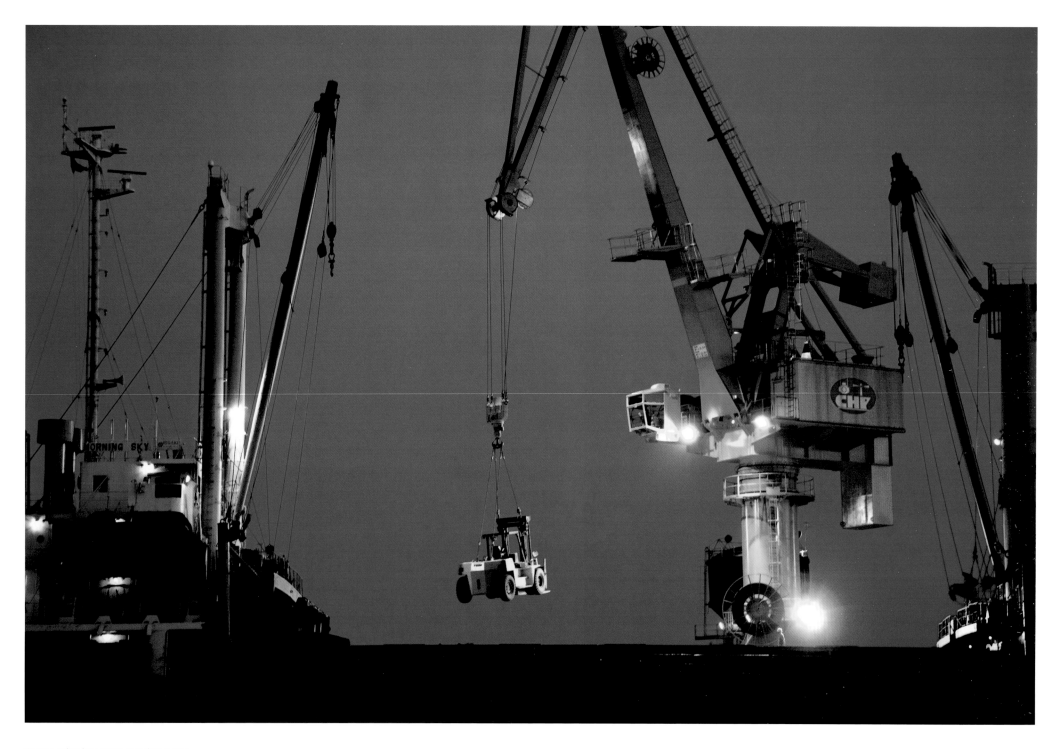

Cranes unloading cargo, Hai Phong, 2011

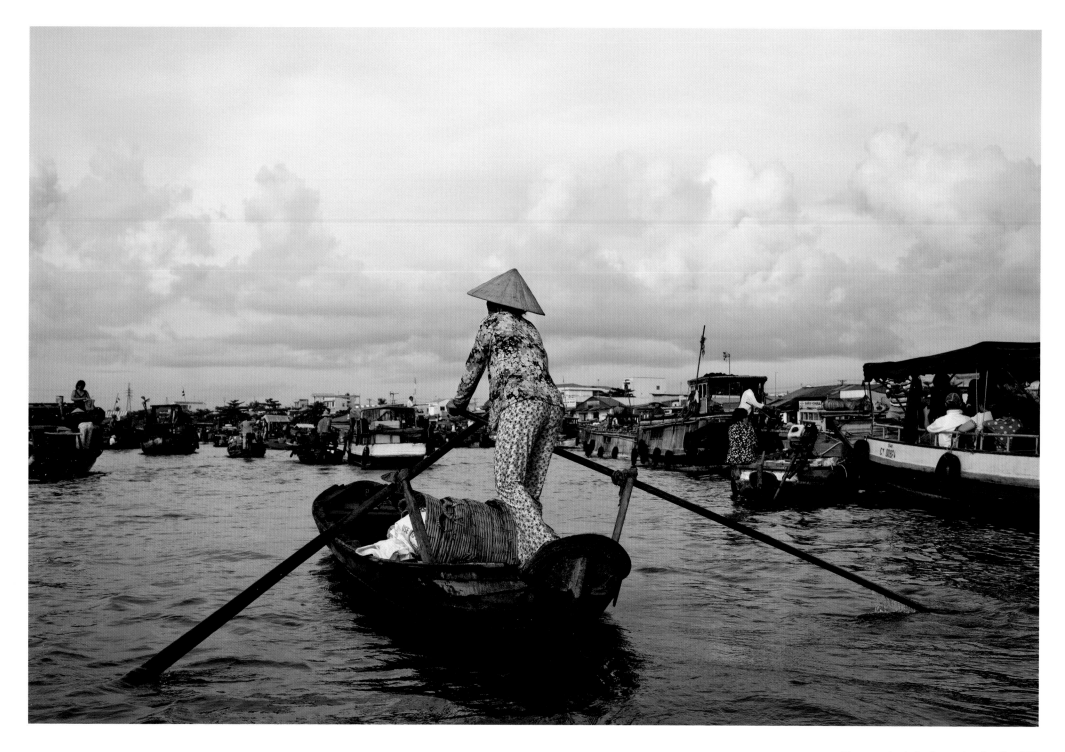

Woman rowing to floating market, Can Tho, 2013

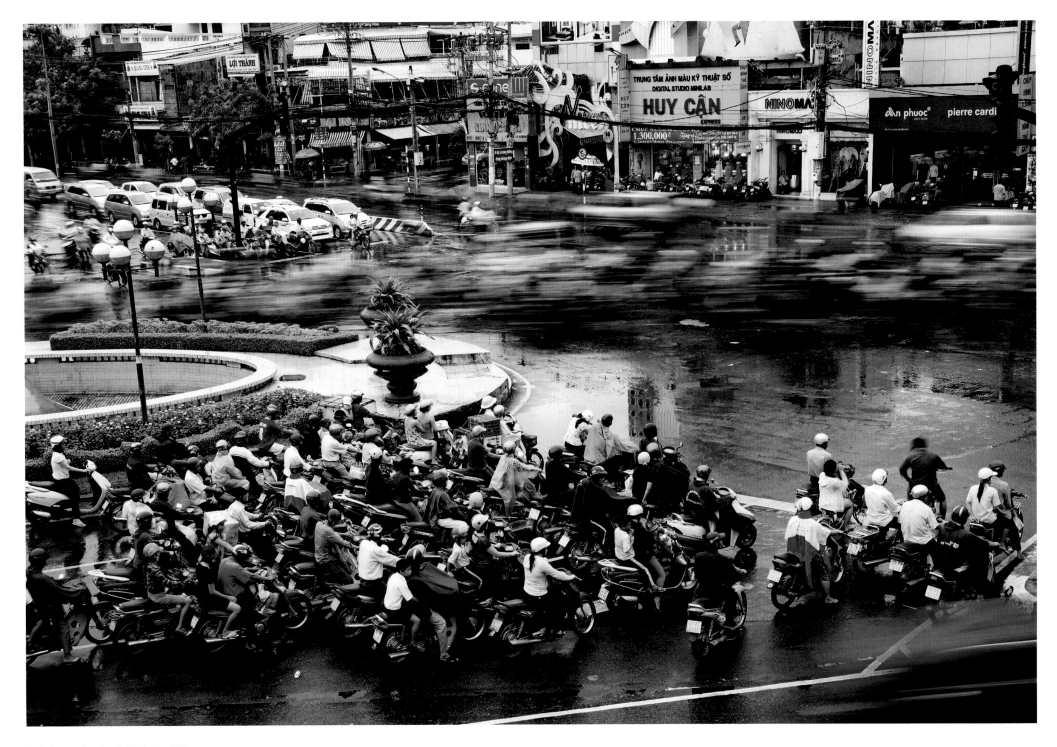

Rush-hour traffic, Ho Chi Minh City, 2011

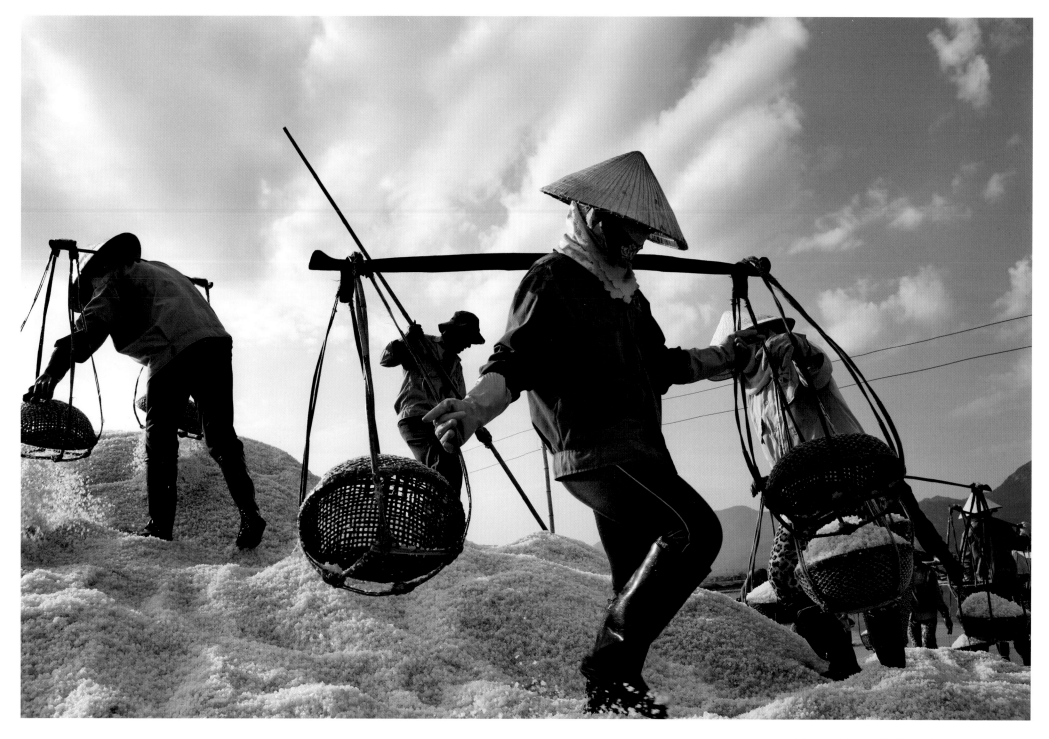

Women mining salt, Nha Trang, Khanh Hoa Province, 2013

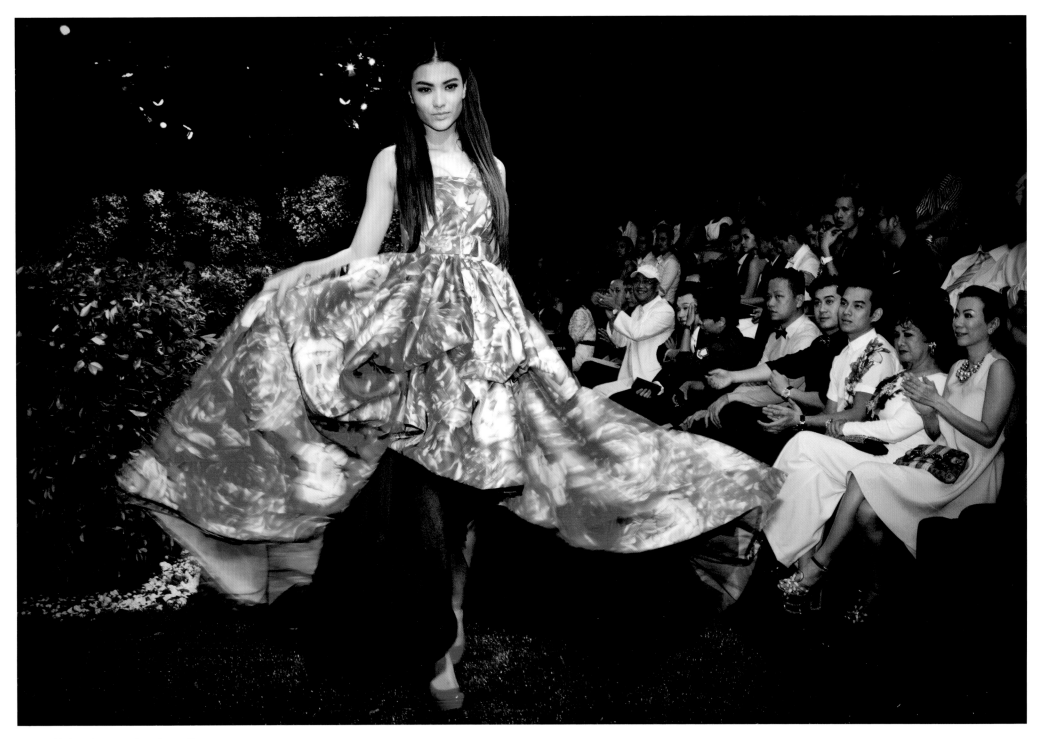

High-end fashion show, Ho Chi Minh City, 2013

VIETNAM 40 YEARS LATER

ANDREW LAM

Four decades have passed since the last U.S. helicopter carrying refugees flew away from a Saigon in smoke, but still the ember smolders. Vietnam is no longer a war, of course, but it remains for many Americans a scar and a haunting metaphor for political disasters and tragic consequences. It evokes memories of napalm, carpet-bombings, burnt-out houses, dead civilians in black pajamas and army helicopters hovering over wounded GIs in rice paddies. And gripped by that ignominious past, Americans often regard my homeland through the eyes of the culpable.

The country called Vietnam, on the other hand, has freed itself from that historic moment. Its population has passed 90 million, more than doubling since the war ended. Fading from living memory and into history, the war is a subject barely talked about. Vietnam, in any case, waged another war in Cambodia in 1979 and occupied that country for the next 10 years. It also fought against the Chinese in 1979 and won. A few years ago, when I asked a young man on the streets of Hanoi how he felt about "the war," he looked perplexed. "Which war, uncle?" he asked. "We had around six last century."

Vietnamese, in fact, don't like to talk about wars. They'd rather talk about business and job opportunities, and the goings-on of their families. Full of young, energetic people, the country is rushing at breakneck speed toward modernity, and its gaze is relentlessly forward.

In a sense, Robert Dodge's *Vietnam 40 Years Later* is a counterbalance to the long-held American view of my country. Dodge, who visited Vietnam nine times in the last decade, has witnessed an enormous change there: rice paddies replaced by condos and golf courses, sleepy fishing villages turned into luxury resorts, old markets transformed into slick, marbled shopping malls.

Indeed, this volume's cover photo itself captures something of the current motif of Vietnam: movement and change. A lone baguette vendor in a strikingly red jacket sits immobile against a blurry river of people on motorcycles. But her immobility is deceptive. Despite her traditional conical hat, despite her stillness, the bread-seller wears modern clothing, down to her Western-style purse. She too, in a sense, wants to move forward. And given that there are 145 million cellular phones for Vietnam's 90 million people—or about two for

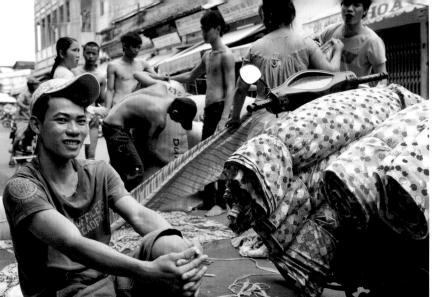
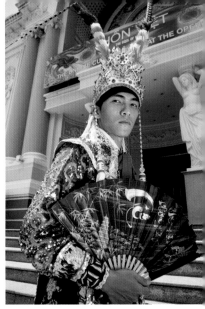

every adult—it wouldn't be at all surprising if she, in the next frame, were to take one out from that purse.

Modernity, that is to say, seeps in. You can see it as a river of motorcyclists rushing by while above them looms a Starbucks sign. Or take a look at the farmer standing in his bare feet on the verdant slope: Two oxen graze nearby, but he is preoccupied with chatting on his cell. Or consider the new cityscape of Saigon, my birthplace, now renamed Ho Chi Minh City, with its high-rises being constructed—and see the once-sleepy town of villas and lycees and tree-lined boulevards transforming itself into a bona fide 21st-century metropolis.

What can we discern from *Vietnam 40 Years Later*? That first and foremost, Vietnam is an active verb. In it, people work and they work hard. In the following pages, you will see Vietnam as a country powered by backbreaking labor—factory workers, fishermen, farmers, market vendors and cyclo drivers—something that has never changed. And women, more often than not, work even harder than men: See them carry baskets of salt, see them row boats to the market, see

them sell fish and flowers, see them harvest rice.

But to the discerning eye, there is a growing schism between the haves and have-nots. There's a Vietnam that is moving toward a conspicuous consumerist culture, a new upper class living a grand life with armies of servants waiting on them hand and foot. Then there's a Vietnam that remains mired in poverty, one in which millions live hand to mouth.

The photo of the young woman in red stilettos walking past the Chanel store in downtown Saigon, for instance, stands in contrast to the image of the tribal woman making sticky rice in her ramshackle mountain home. A purse in that Chanel store could easily purchase 10 impoverished children in the Mekong Delta, where desperate parents have been known to sell their daughters across the borders to human traffickers—for a mere $400. Indeed, despite enormous changes and economic progress, there's a gigantic gap between those who work to survive and those who own villas and fly overseas to shop 'til they drop. In the age of raging red capitalism, Vietnam is a country of humiliating poverty and extraordinary if increasingly unwarranted wealth.

What else? Vietnam is a world in motion, in flux. You can see this simply by looking at Dodge's gorgeous photograph of the gigantic billboards that line the bank of the Bach Dang River. They have phone numbers on them; they are waiting for potential marketers—Tiger Beers, Starbucks Coffee, Sanyo—to place their ads. You can see it in the fashion show that the upper class enjoys, the nouveaux riches applauding the model flourishing her red skirt into a blossoming hibiscus on the catwalk. You can see it in the gigantic crane at the dock lifting a forklift truck to shore. And you can see it in the stylish entrance of the brand new Melbourne-based RMIT university campus, which recently opened in Vietnam to offer programs from business and management to design and micro-engineering.

Yet still, in Dodge's photos, I am heartened to see that my homeland remains as much a breathtaking beauty as she ever was. She's made of majestic mountains shrouded in the morning fog, of sand dunes under tropical sunlight, of limestone karsts and isles, and she's shaped by the eternal sea lapping at her shore. And she is not always about work: She's

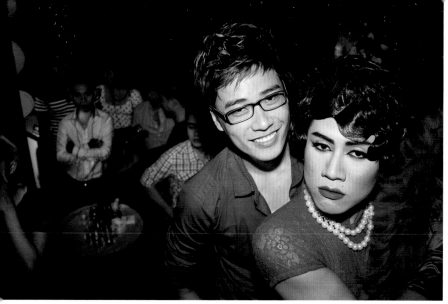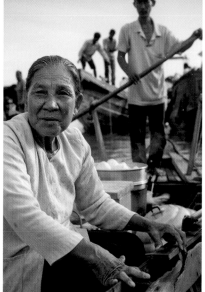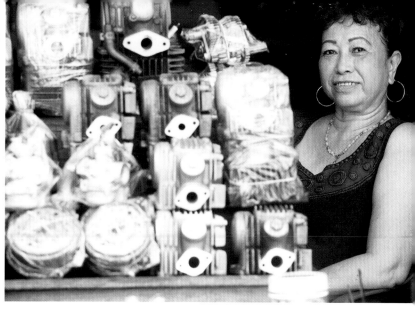

also made of smiles and laughter, of leisure and of celebrations. The temples and churches are always full of worshippers on religious holidays. Over food and drinks, fishermen gossip and chat after a hard day's catch. For Tet, the Lunar New Year, parents and children dress up and walk the streets in jubilation. And it is a statement on Vietnamese spirituality and a deep sense of aesthetics and religiosity that flowers are always in high demand at the market.

My two favorite photos: A Buddhist monk sits on the tile floor, smoking a cigarette. He peers out to a bright world through a door ajar, the smoke drifting lazily. Part of his saffron robe, lit by sunlight, seems like it is made of fire itself. And there's the gorgeous image of the oxen race of Chau Doc in the Mekong Delta. The oxen are harnessed together in pairs. Team 45 is leading, team 44 catching up from behind. The muddy water splashes upward, a rising curtain in blistering sunlight; see the enviable joy on the racer's face.

For Dodge, no doubt, it is a difficult task to pick from the thousands of images he took in my country. What to leave out? Gay lovers? Internet cafes? Sidewalk prostitutes? Street

protests against an authoritarian regime? Luxury resorts and beaches? What about the new McDonald's that just opened? Or that beauty weight-lifting contest? After all, anyone who wants to describe Vietnam knows that one cannot fully chronicle a raging river. The complexity of Vietnam will always elude efforts to capture her.

Vietnam 40 Years Later is people-centered, however, to its credit, and thereby manages to depict a new historical moment: a country at a crossroads, one that is part of the global society and yet, like the farmer talking on the cell phone, one that still has its feet in the mud.

That a book of photographs narrates the human dimension of Vietnam at an important historical juncture is, therefore, very welcome. No doubt it will help loosen the grip that wartime memories have on those who still hold tightly to the "What we did to them" lens. At the very least, *Vietnam 40 Years Later* should help expunge images of napalm and burnt-out villages and dead soldiers. Let it be known that after the B-52 bombs fell, life goes on—indeed, thrives. The craters have, after the monsoons, turned into ponds in which

farmers raise fish, and in which ducks and children swim; the broken wings of a downed airplane have become rusty bridges across small rivers, connecting neighbors and villages.

Franz Schurmann, well-respected historian, sociologist and world traveler, once observed that you cannot fully understand a society unless you watch "lives lived every day." That is, the way to understand the dynamic of nations is not simply to eavesdrop in the corridors of power, but to chronicle and detail the energy and movements on the street. "The collective soul of the people gives direction to the nation," he said.

Applaud the photographer, then, for his unwavering curiosity as he navigates the neighborhoods and streets and cities and landscapes of Vietnam. Admire these photos, and see them as snapshots of an unfolding epic. See them, if you will, as an invitation to travel, to see Vietnam of the here and now, and as a topography of a once-wounded nation, now healed; a barely discovered country.

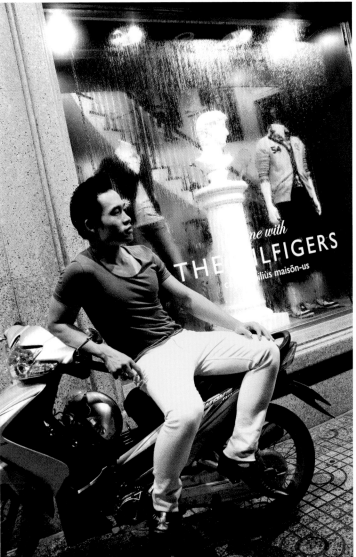
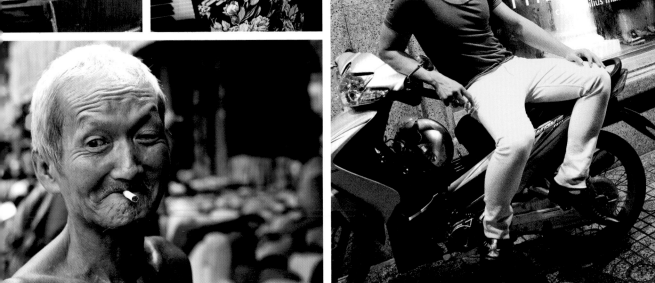
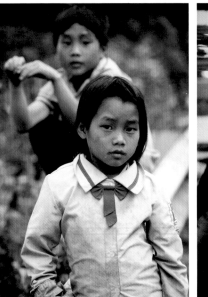

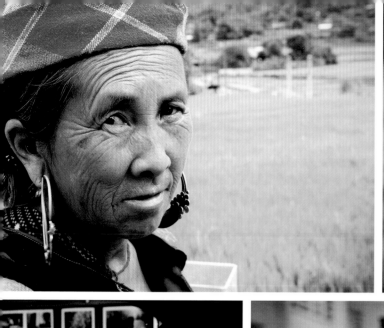
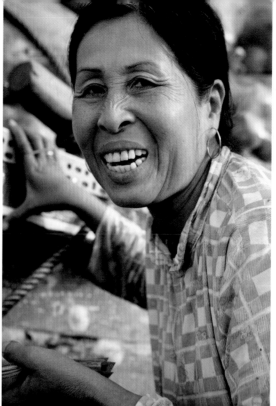
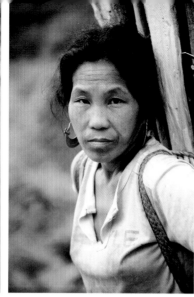
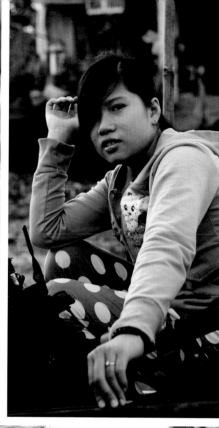
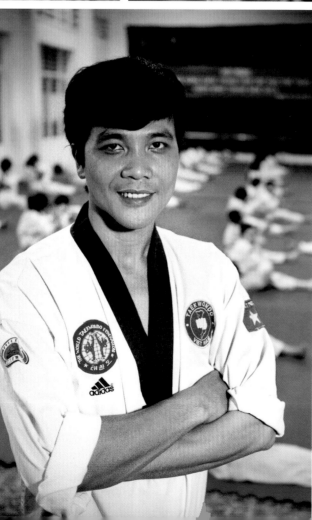
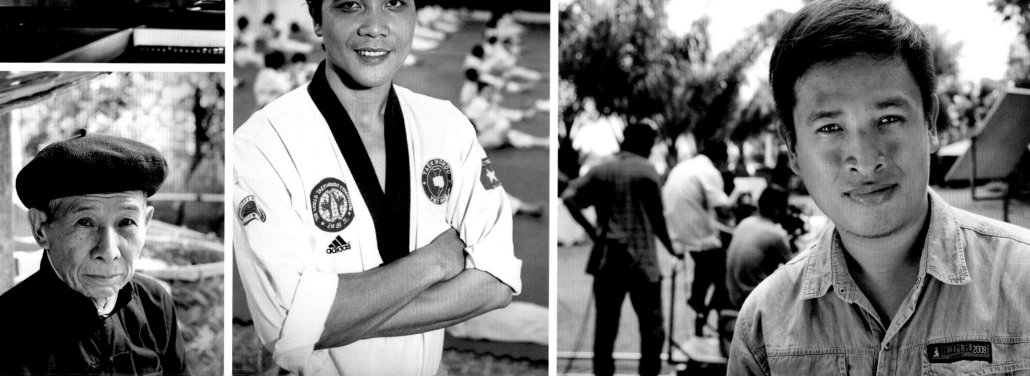

VIETNAM AT A CROSSROADS

ROBERT DODGE

During the early 1970s, the Nixon Administration instituted a draft lottery to determine who would be inducted into the military. It was an era of high-anxiety for young men like me who were not eager to be sent to Vietnam. I got lucky, drew a high draft number and avoided military service.

Even so, Vietnam and the war had a demonstrable effect on my life, as it did for many of our nation's 77 million Baby Boomers.

As we recognize the 40th anniversary of the April 30, 1975 end of the war, this personal photo exploration of Vietnam reintroduces Americans to this Southeast Asian nation. Here I offer a Vietnam free of the war era's Huey troop 'copters, B-52 bombers and bloody jungle treks. Unfolding on each page of this book is a colorful and compelling story of a nation clearly in motion but also at an important crossroads. A country with rolling tropical mountains, clear-water beaches and bustling cities. A country with one foot firmly anchored in Ancient Asia, another leaping forward to embrace the modern world.

My own connection with Vietnam started in the late 1960s. As I made my way through high school and college, the news media was dominated by coverage of the war in Southeast Asia. Magazines like *Life* and the *Saturday Evening Post* were full of riveting photojournalism about the war. At the same time, details of the conflict, and the increasing opposition to it, poured into our homes during the nightly news—coverage that stoked opposition to the war and galvanized my interest in politics and journalism.

Those big magazine spreads and the colorful photojournalism they featured didn't just shape my career path back then. Much later, they would reach out from the past to send me in yet another direction. In 2005, at the end of my first trip to Vietnam, I was confronted with those pages again during a visit to the War Remembrance Museum in Ho Chi Minh City.

As I looked at the magazine spreads in the glass museum case, I experienced a true moment of serendipity. This was no accident. The forces of the universe had conspired to bring me here, to bring me full circle in life. I knew then that my first trip was the first of many, that my interest in Vietnam would not be a passing curiosity. Even though I lived nearly 10,000 miles away, I decided to undertake a photographic exploration of this fascinating place.

I have found here a country on the go, one with a youthful population that is eager to be part of the modern world and who place a high priority on being friends with the United States. Many are too young to have any first-hand memory of that war, but are still proud that Vietnam stands as an independent nation after winning it—and expelling the French, the Chinese and Cambodia's Khmer Rouge. And they share their government's goal to become a modern, industrialized society by 2020.

Vietnam has made enormous progress since 1986 when it instituted the political and economic reforms known as the Doi Moi. It has transformed itself from one of the poorest nations in the world, one with a per capita income below $100, to a lower-middle-income country. It has become a first choice, over China, for light manufacturing, attracting investments from global names like Intel, Nike and Unilever. And there is a growing class of newly rich Vietnamese who are amassing fortunes from home-grown businesses.

At the same time, Vietnam has assumed a leadership role in regional economic development organizations. And its government appears to be working hard at creating economic ties with the United States, as well as with many countries in its Southeast Asia neighborhood.

But now, 40 years after the war, Vietnam stands at a crossroads. Its ambitions to be an economic and political power in the region are being undermined by self-inflicted setbacks, including human-rights abuses, rampant corruption and mismanagement of its partially free-market economy.

First, its entrenched bureaucracy had to put the brakes on an inflationary spiral fueled by rapid growth, which required an appropriate but painful period of high interest rates. That policy brought its fever-pitch real-estate market tumbling down. Now the country's former Communist leaders are trying to sort through complex economic problems Ho Chi Minh could never have imagined, including a glut of empty residential and commercial real estate in Hanoi and Saigon that has saddled its state-controlled banks with portfolios of rotten property loans.

Slower economic growth has stirred discontent among Vietnamese unhappy about fewer job opportunities and

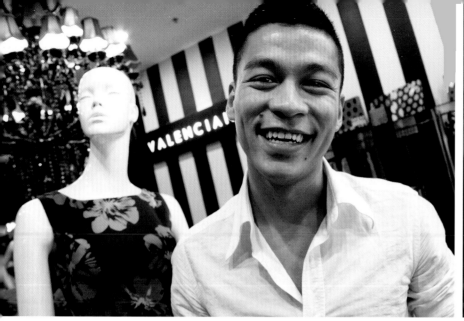
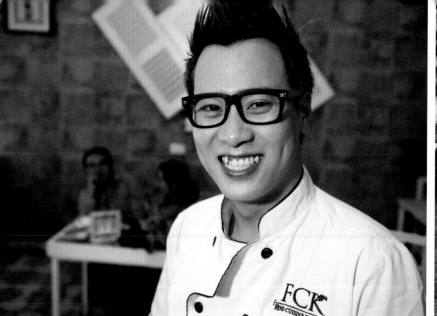

the rising cost of goods and services. And for at least two years the government has waged a troubling crackdown on dissent by political bloggers. In 2013 alone, heavy prison sentences were imposed on about 40 dissents who criticized the government's attempts to forge better relations with China. And having seen the role social media played in the Arab Spring, nervous officials tried limiting the use of social media with perplexing and ineffective regulations that prompted one technology writer to dub the regime "Enemies of the Internet."

The government has responded to those economic problems by making plans to privatize more state-owned businesses and seek new foreign investment. No doubt these initiatives will lead to new growth. But the world is watching to see if Vietnam's one-party regime will also make human-rights reforms and take steps to clean up the corruption that pervades its bureaucracy from the senior levels of government down to the beat policemen on the street. There is no question that dramatic improvements must be made if Vietnam is to realize its full potential.

Yet there is hope. The government's clumsy attempts to regulate Internet access and suppress news are failing, and the country's youthful population is increasingly connected with the rest of the world. They have gotten a taste of economic success, breathed the air of freedom and indulged themselves in the pop culture of the West. There is no going back.

Despite such profound changes, America's own ideas and perceptions about Vietnam are still built around the imagery of war. Those images linger as our icons of Vietnam, underscoring that our country has never fully healed from the conflict there—a war that deeply divided our people, claimed the lives of 50,000 Americans, and hobbled our ability to respond to foreign crises.

Perhaps America's final steps in healing from this tragic war will be found in rediscovering Vietnam, this time not as the name of a war but as a country with a rich culture and vibrant people. To be sure, we should never forget the sacrifice and suffering that was captured in wartime imagery. It is part of our history, and our servicemen answered the call of their country and fought there bravely and with great courage.

But now is a time for healing. And that requires reconciliation. And reconciliation requires knowing and understanding.

I sincerely hope that this book provides an avenue to greater understanding. That it will show we are again linked to Vietnam, this time peacefully through economic trade, cultural exchanges, renewed connections between Vietnamese and Vietnamese-Americans and through millions of connections via the Internet and social networking.

In 2011, my own journey took me to the family kitchen of Loc Tai in Hai Phong, the country's largest deepwater port. Huge container ships line the waterfront, taking on their cargo of manufactured goods from Vietnam's community of assembly plants. Tucked in a cove off the main harbor, Loc

operates a small marine-repair business. He made it possible for me and my assistant, Khoa Tran, to tour Hai Phong harbor by boat and then invited us to stay for dinner at his home. After an afternoon of shooting on the harbor, we sat on the floor of his kitchen, the men drinking and eating while his wife and daughter served chicken, pork and rice.

After a few beers on ice and shots of wine aged with herbs and roots, Loc asked my age, and if I had served during the war. I explained that I had had a student deferment, and hadn't served in the military. Loc said he joined the North Vietnamese army, but never saw combat because the war ended while he was in basic training. "They were a bunch of Communists," he said with obvious disdain.

Loc's remark surprised me. I asked him if he had seen the war as a battle between democracy and communism, or if for him it had been more about winning Vietnam's independence from foreign occupants. Again, he surprised me, and said it had nothing to do with ideology.

"Food was scarce then, and we were starving," he said. "I joined the army so I could get fed each day, and it helped my family by eliminating one mouth that they no longer had to feed. But I did not care about the war."

Loc and I agreed that meeting 40 years later over dinner was preferable to meeting on the battlefield. There was a round of toasts. We shook hands and observed a few seconds of silence, our shared moment of remembrance for those who could not be there.

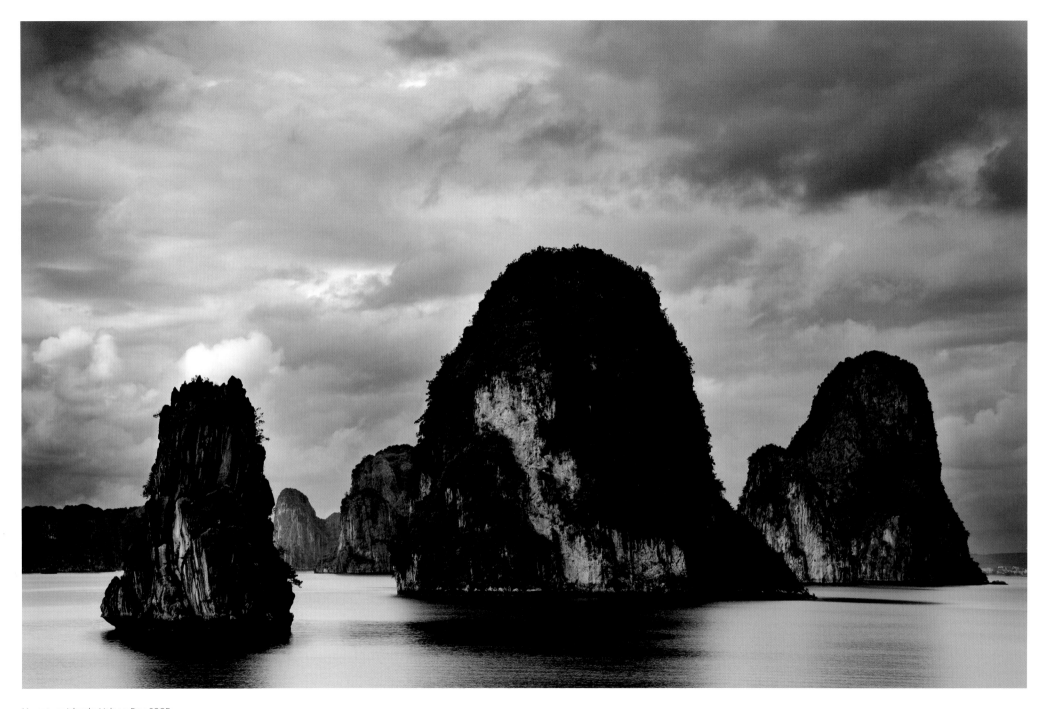

Limestone islands, Halong Bay, 2005

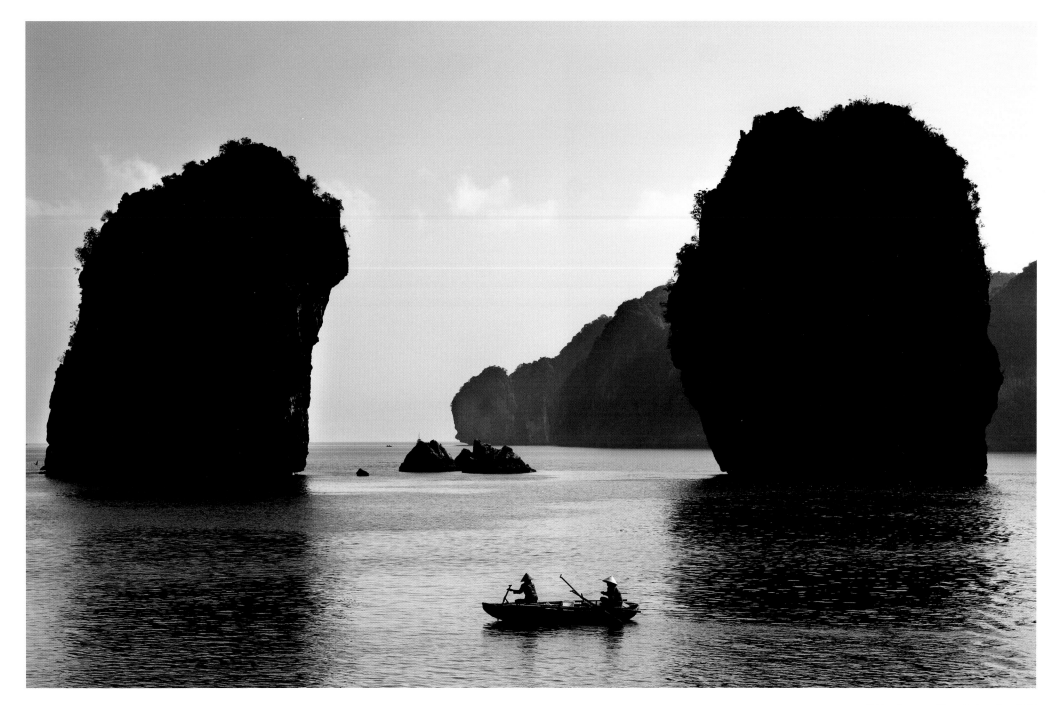

Fishing from small boat, Halong Bay, 2005

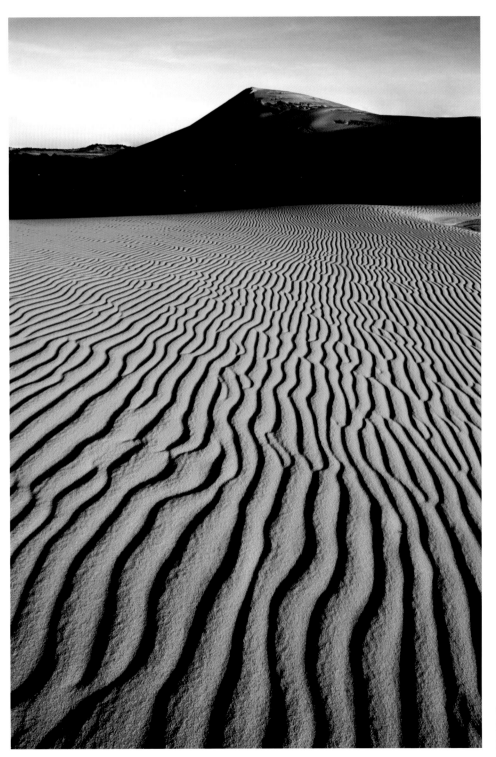

Sand dunes
at sunrise, Mui
Ne, Binh Thuan
Province, 2006

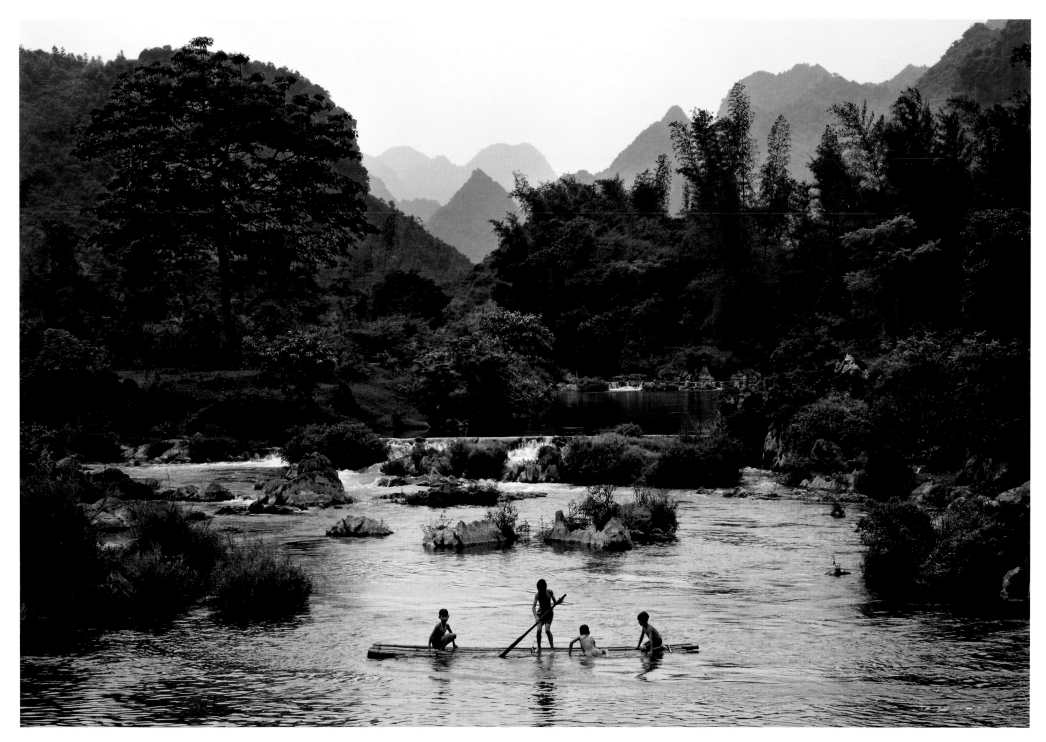

Boys at play, Cao Bang Province, 2008

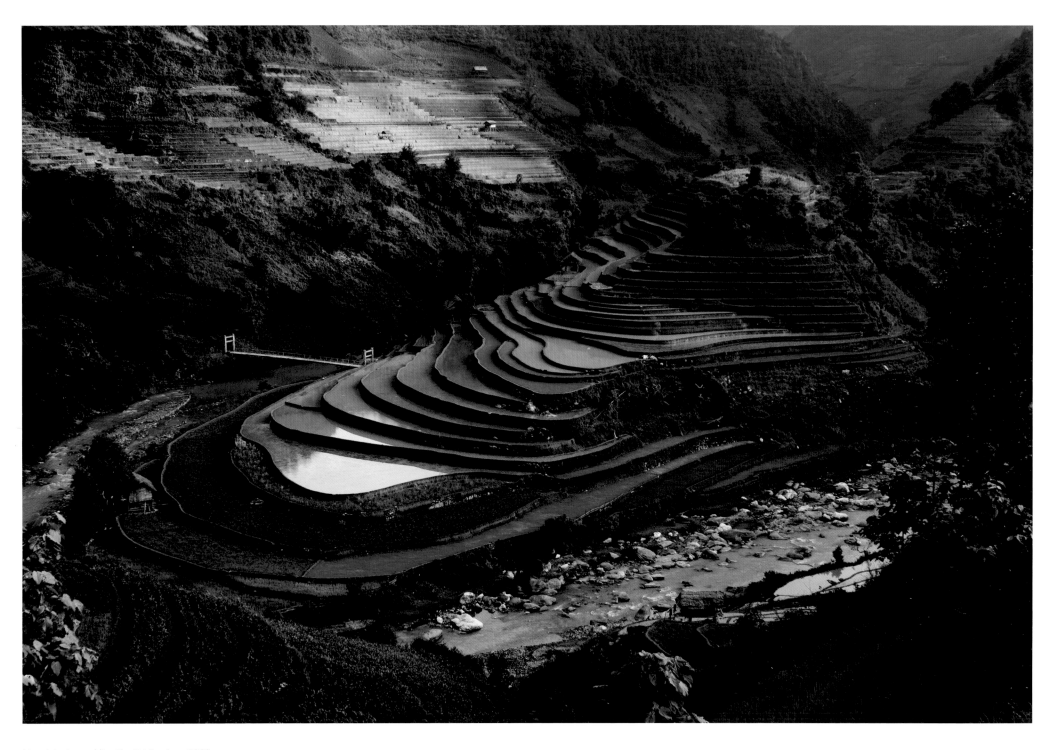

Mountain rice paddies, Yen Bai Province, 2009

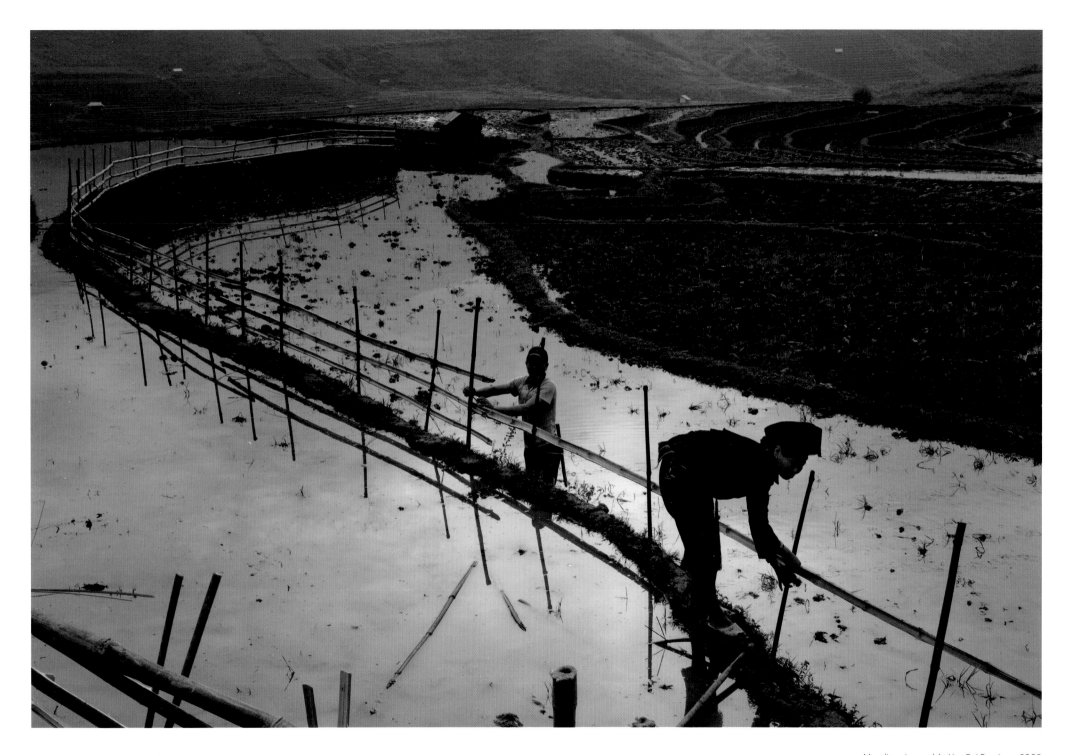

Mending rice paddy, Yen Bai Province, 2009

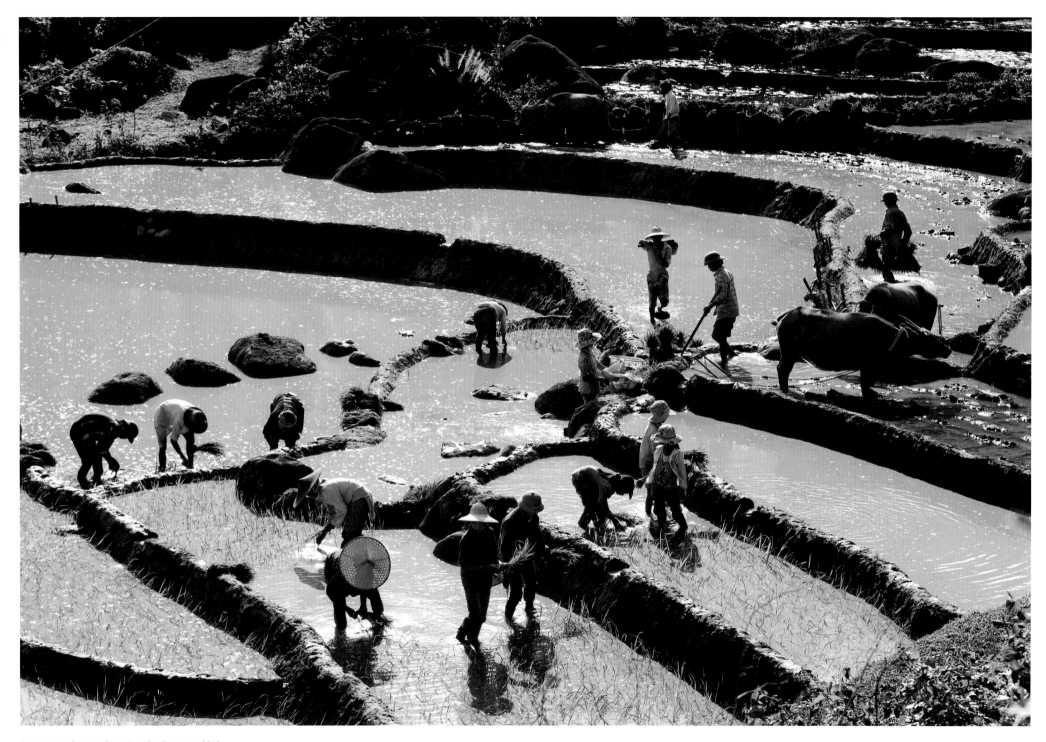

Spring rice planting, Sapa, Lao Cai Province, 2013

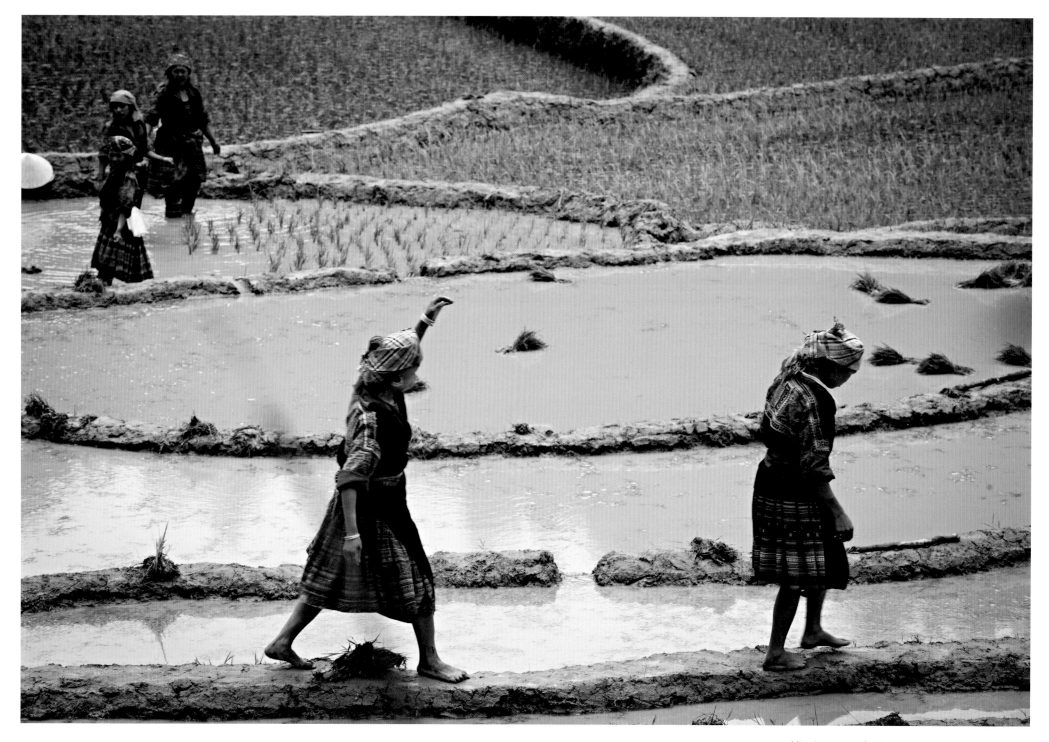

Minority women planting rice, Sapa, Lao Cai Province, 2013

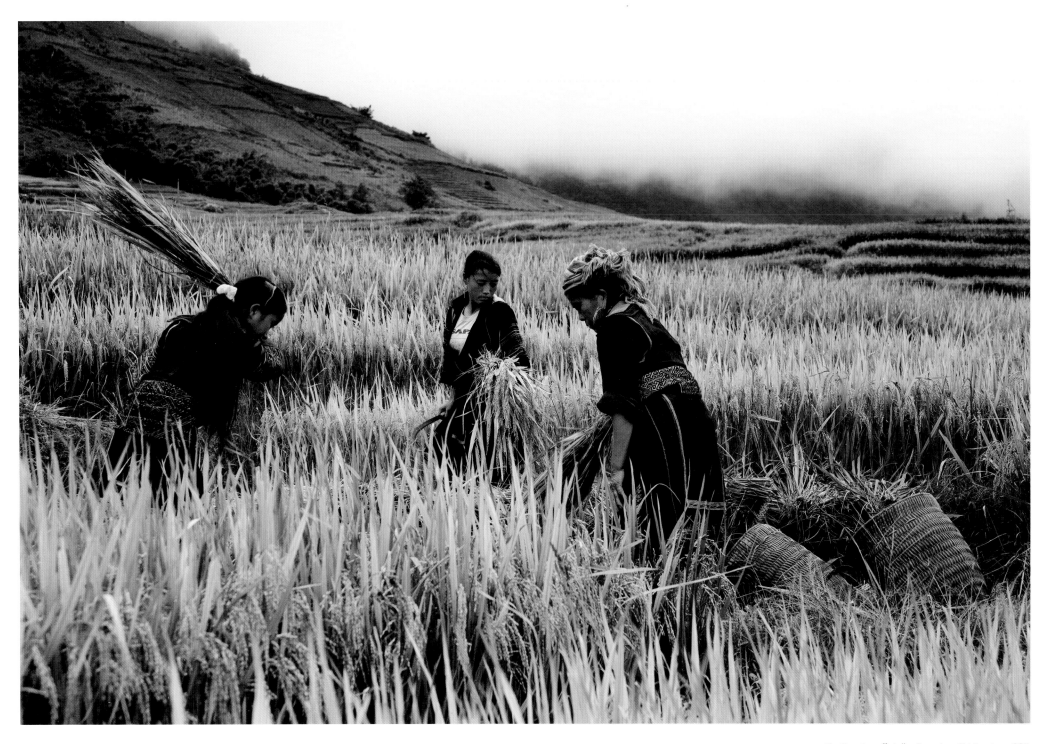

Beating rice off stalks, Sapa, Lao Cai Province, 2011

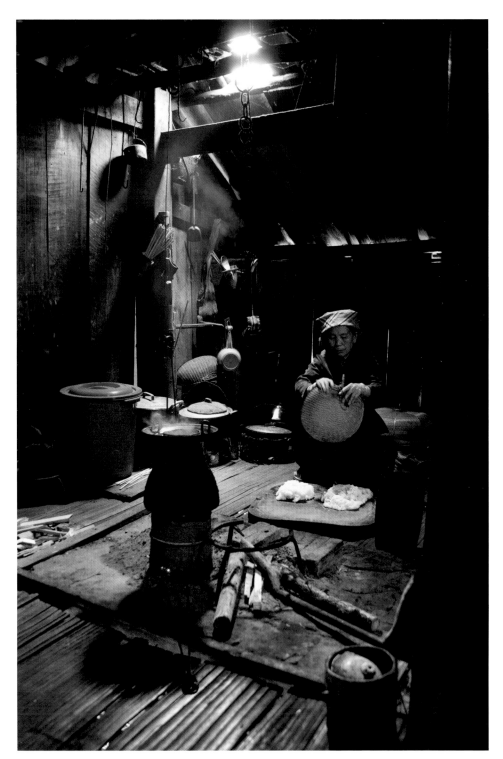

At home making
sticky rice, Mu
Cang Chai, Yen
Bai Province, 2011

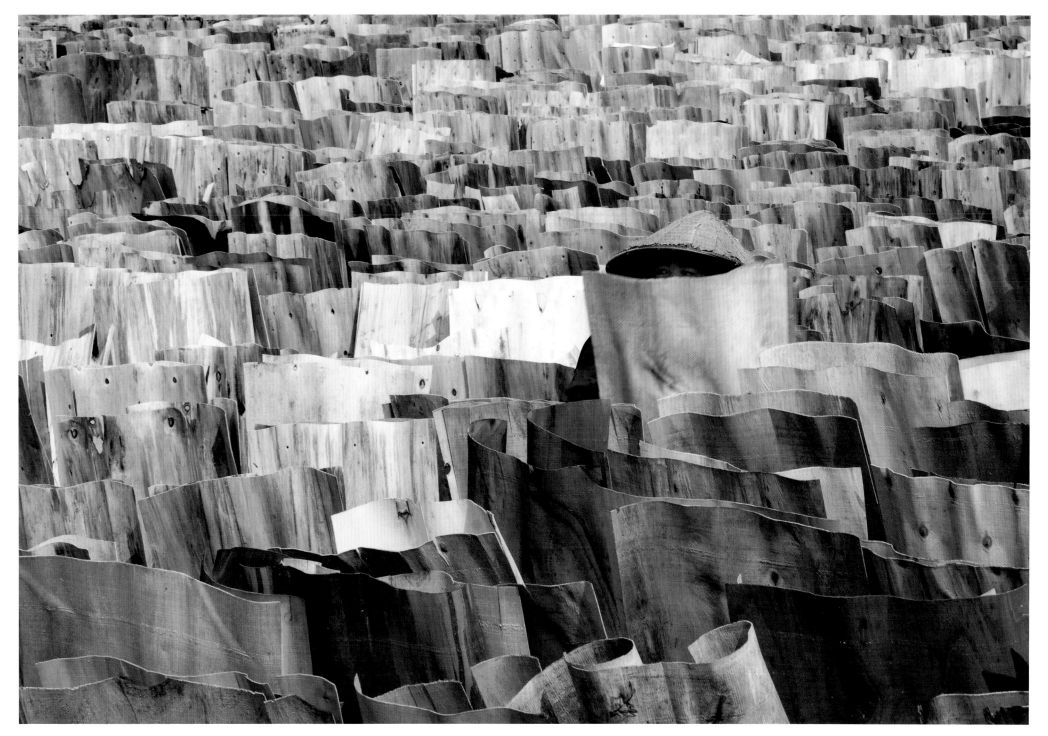

Drying wood veneer, Phu Tho Province, 2009

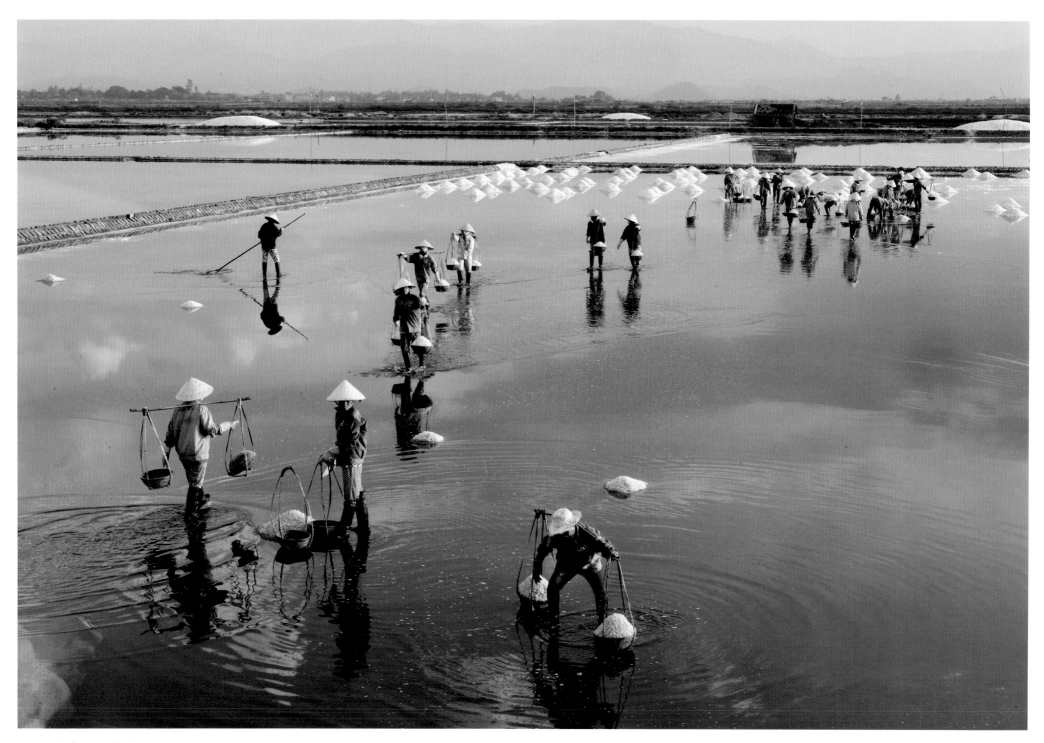

Mining salt, Nha Trang, Khanh Hoa Province, 2013

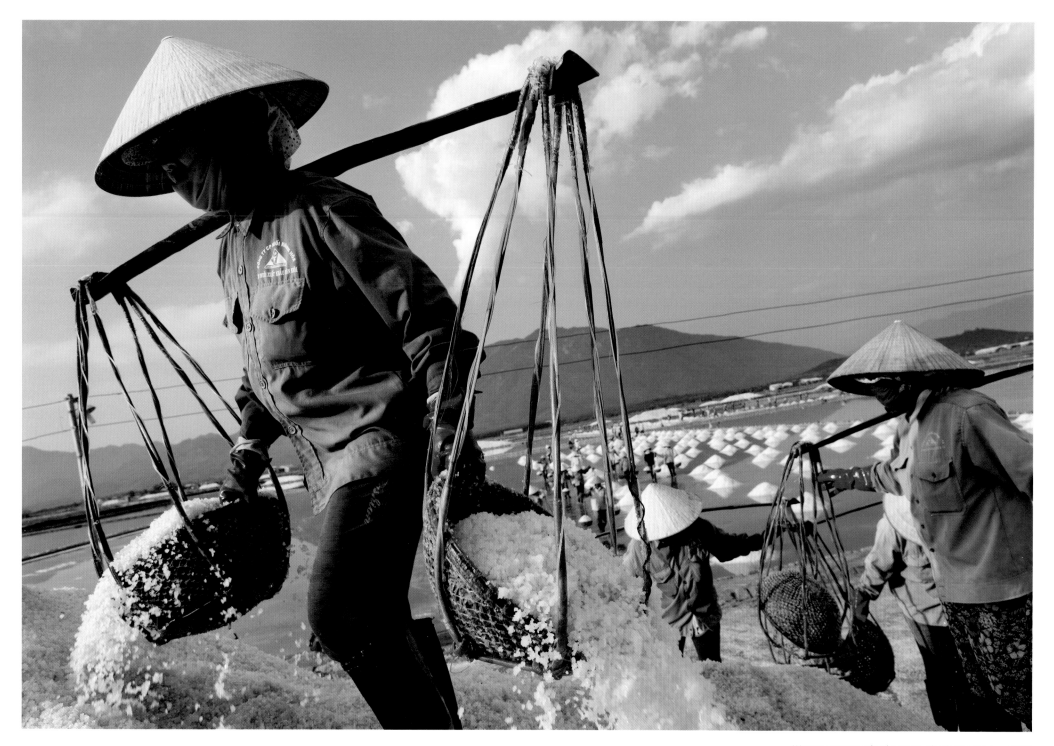

Women carrying salt, Nha Trang, Khanh Hoa Province, 2013

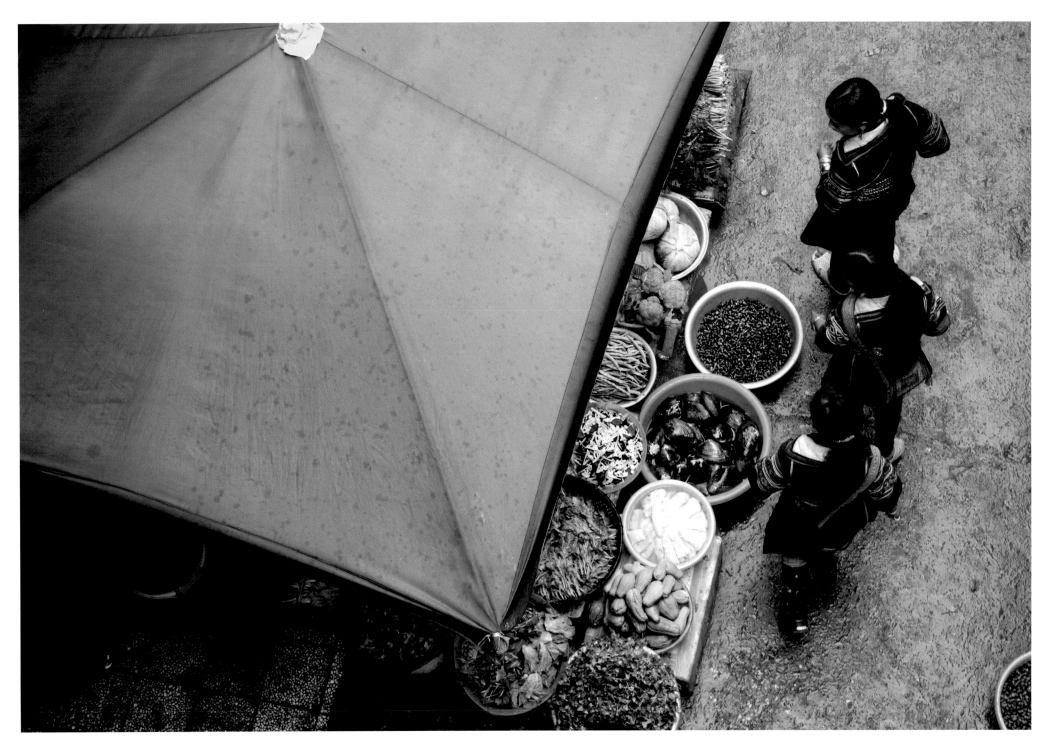

Minority women shopping, Sapa, Lao Cai Province, 2005

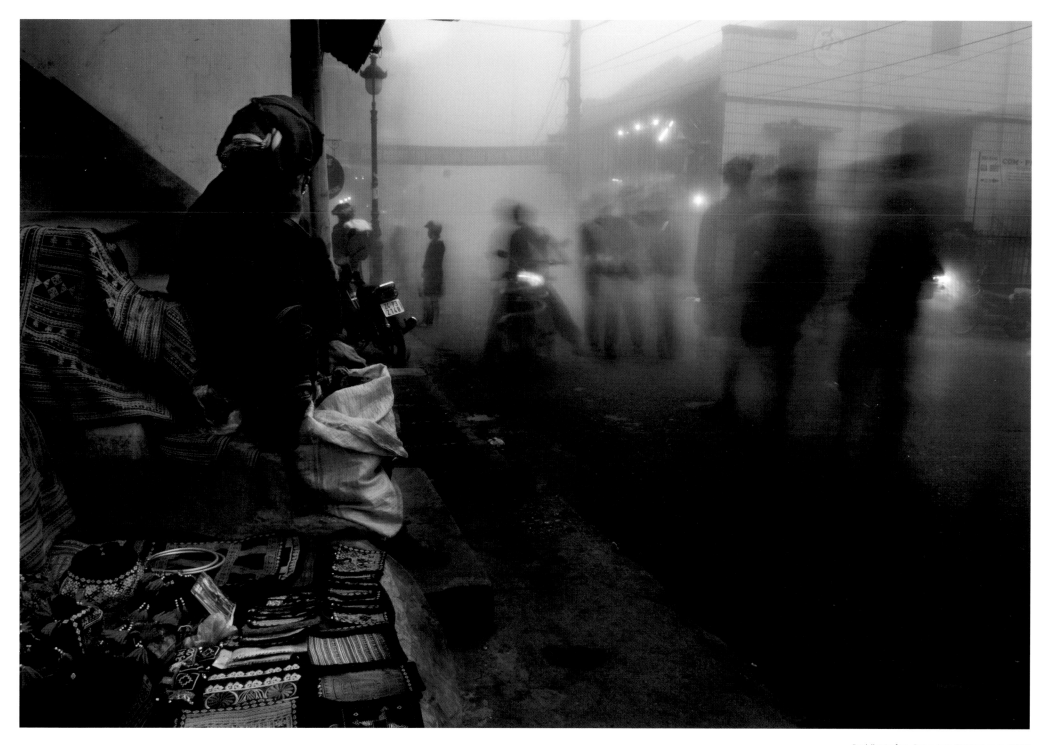

Peddler in fog, Sapa, Lao Cai Province, 2010

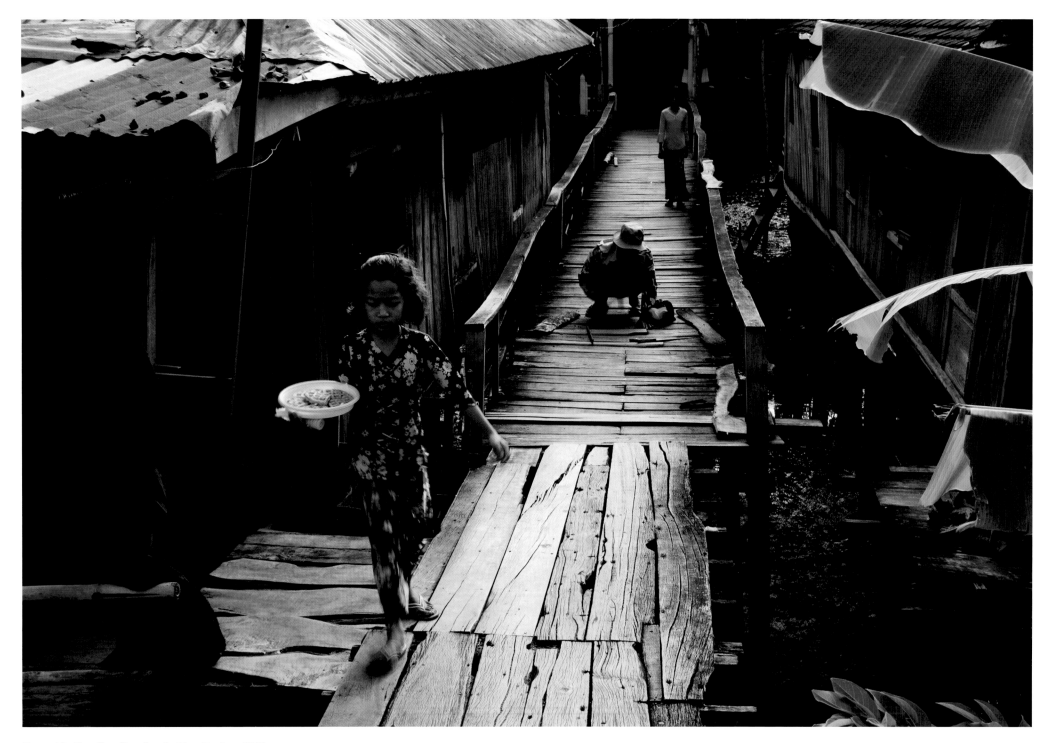

Khmer girl with waffles, Chau Doc, An Giang Province, 2006

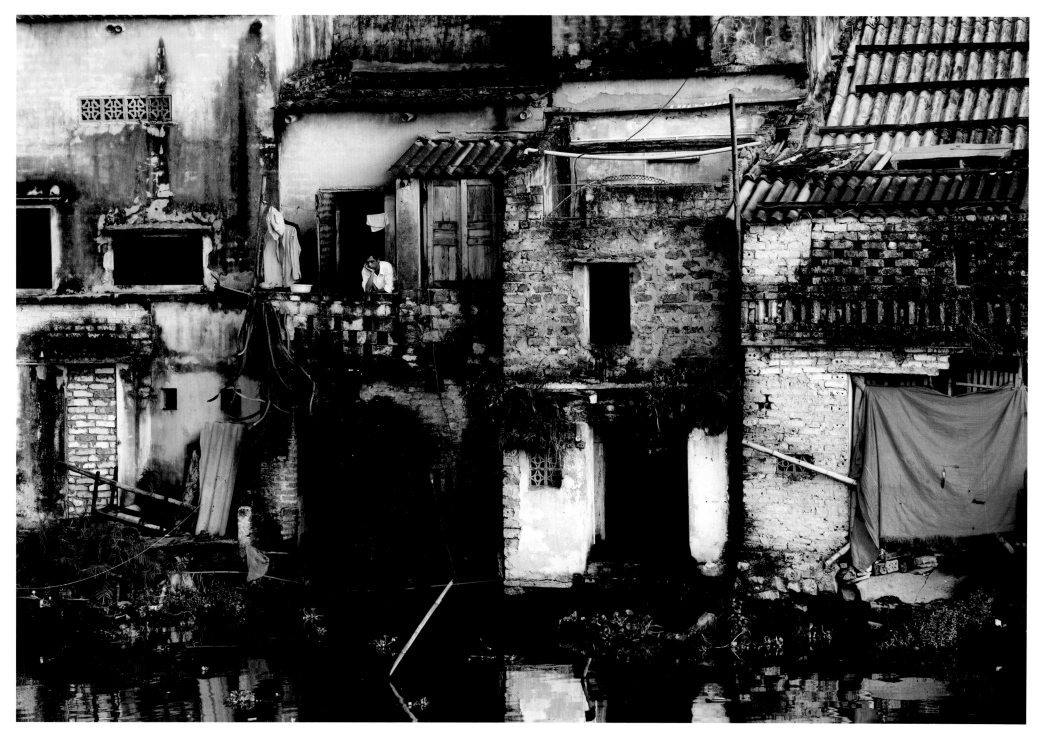

Squatter housing, Ninh Binh Province, 2006

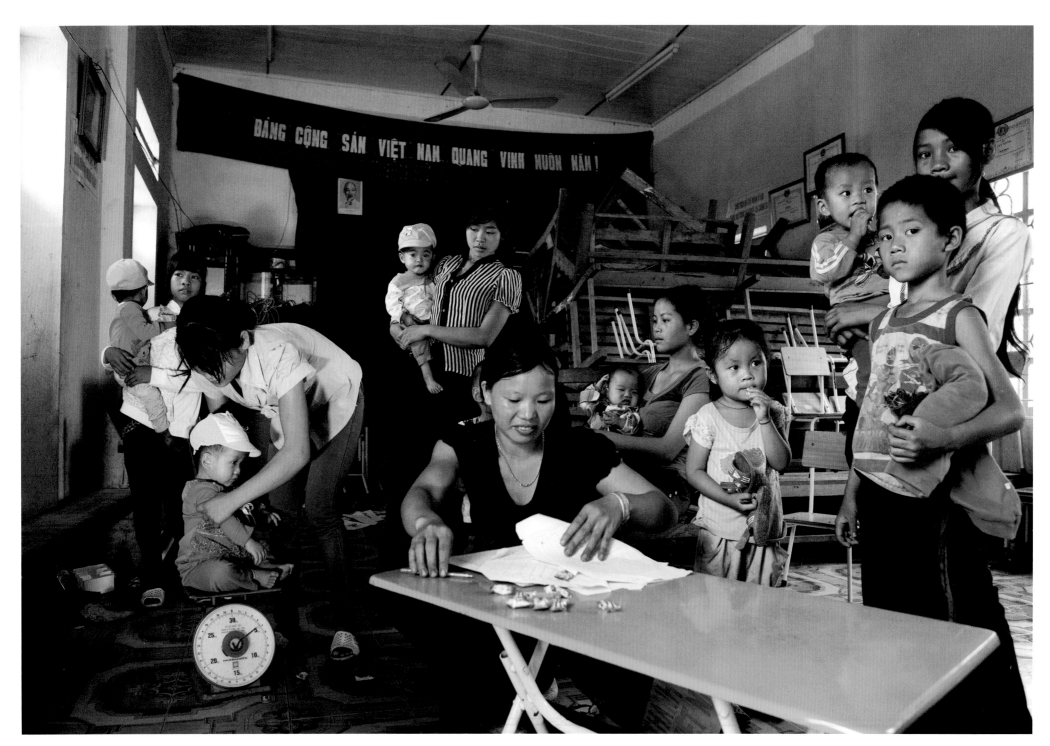

Weighing and measuring pre-schoolers, Yen Bai Province, 2013

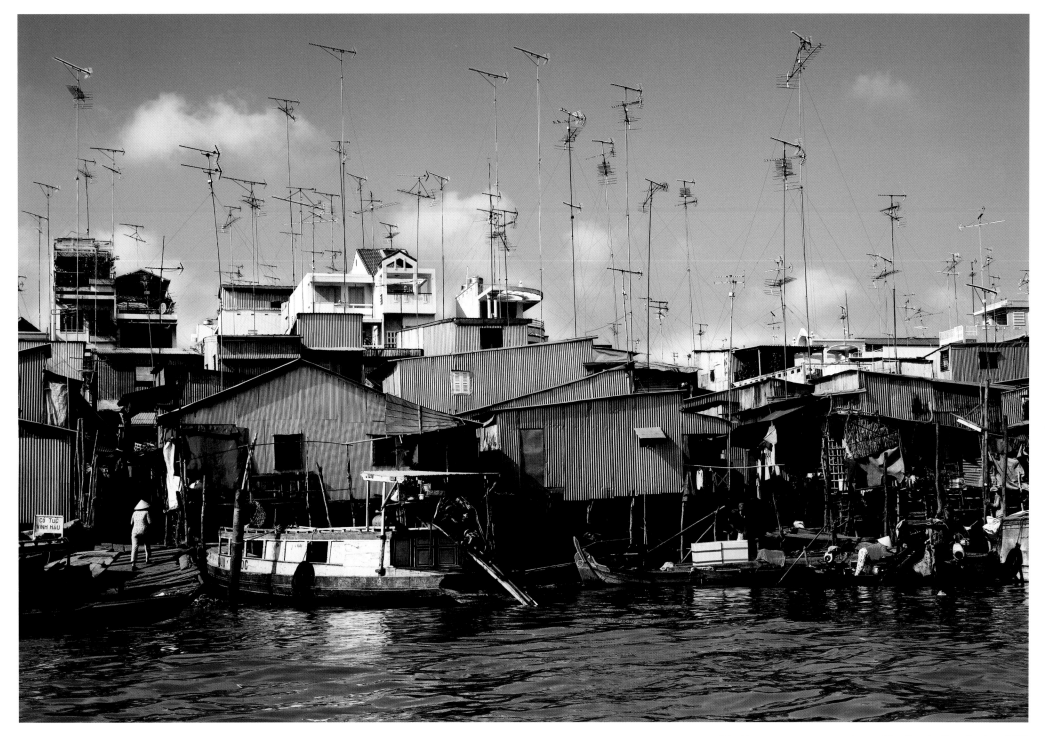

Television antennas on squatter homes, Chau Doc, An Giang Province, 2006

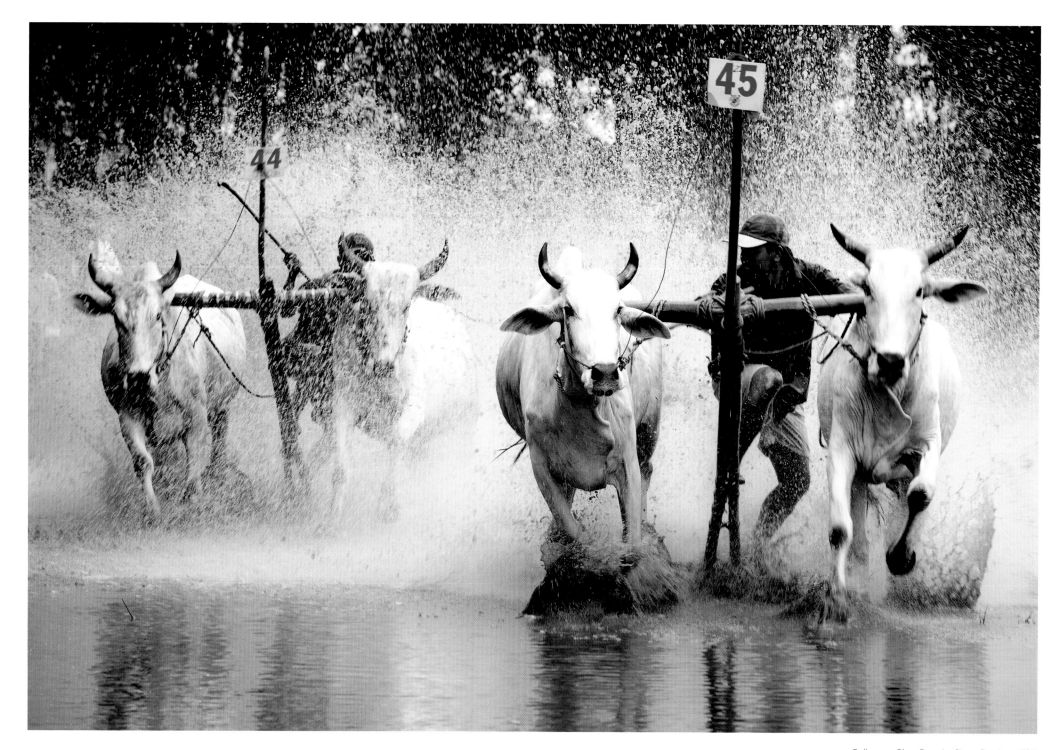

Bull races, Chau Doc, An Giang Province, 2011

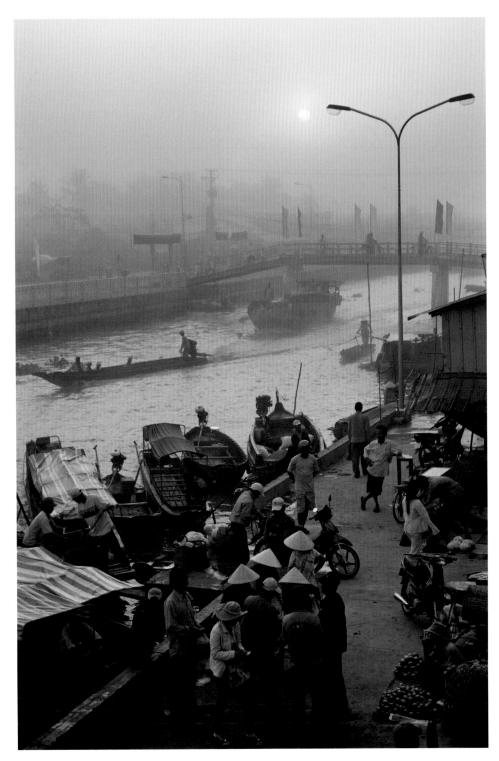

Early morning
market, Nga
Nam, Soc Trang
Province, 2010

Ferries crossing
the Mekong,
Can Tho, 2010

Woman operating
water taxi, Nga
Nam, Soc Trang
Province, 2010

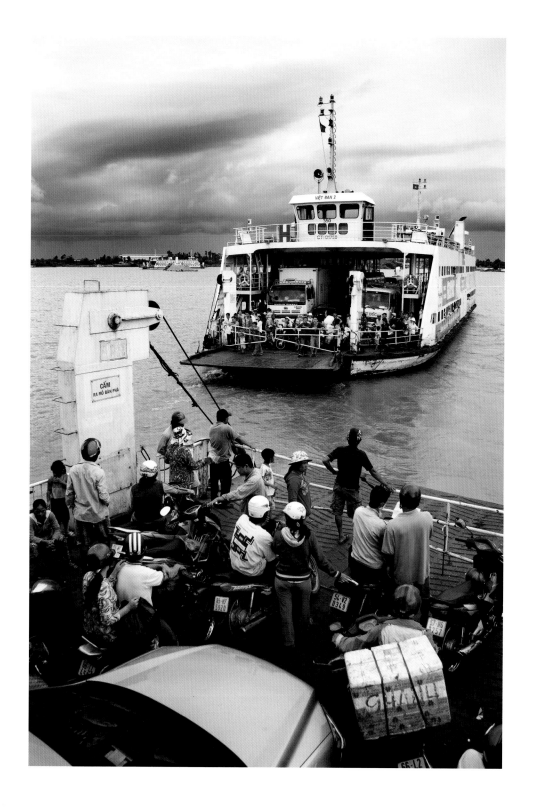
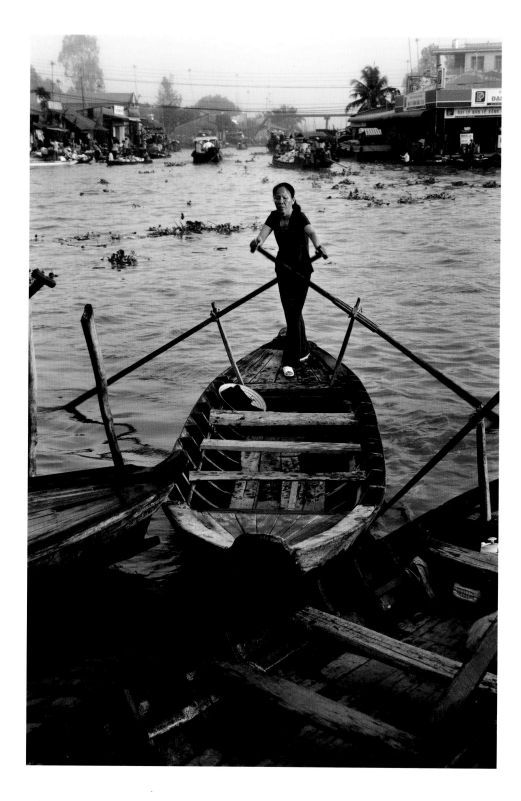

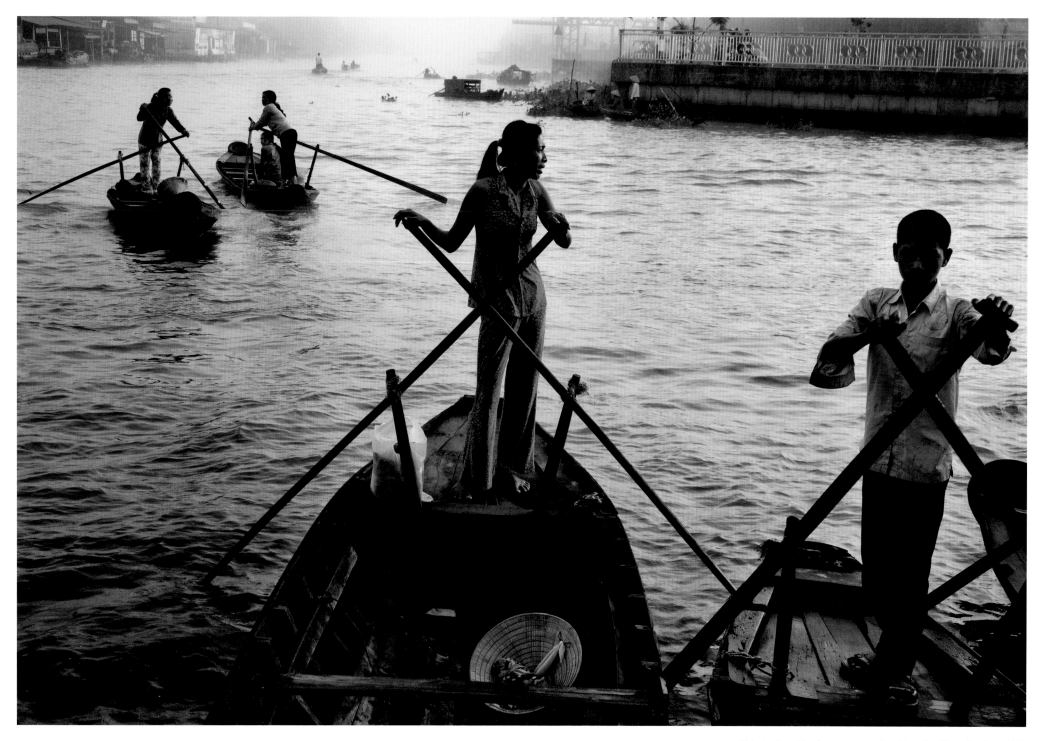

Water taxis waiting for passengers, Nga Nam, Soc Trang Province, 2010

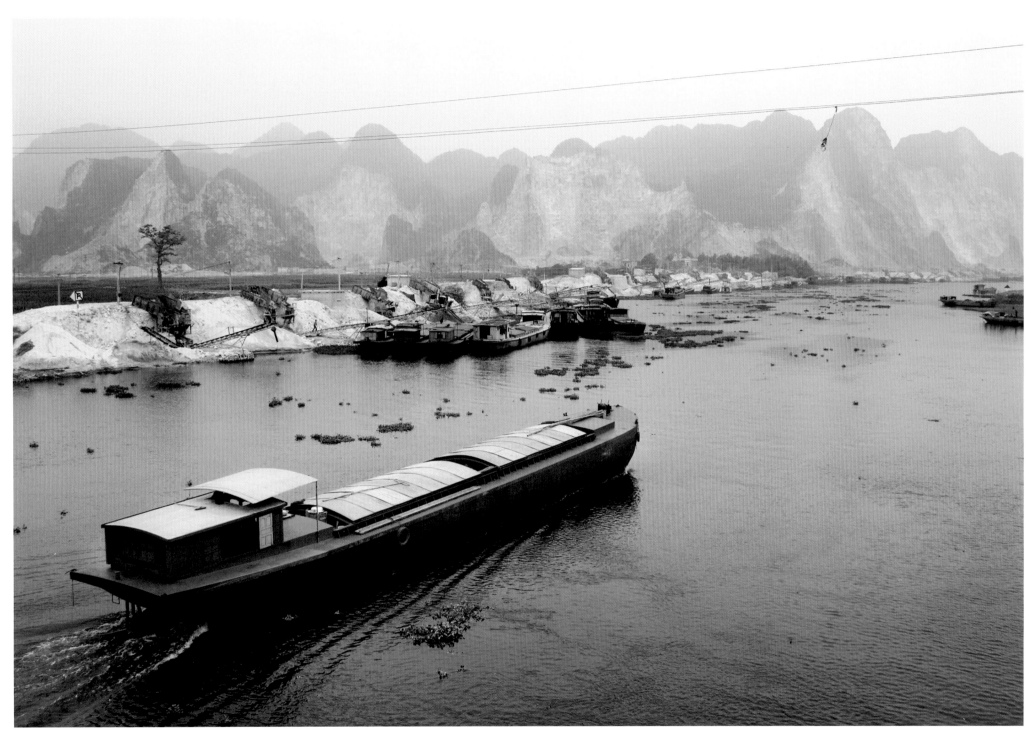

Mining limestone, Ninh Binh Province, 2006

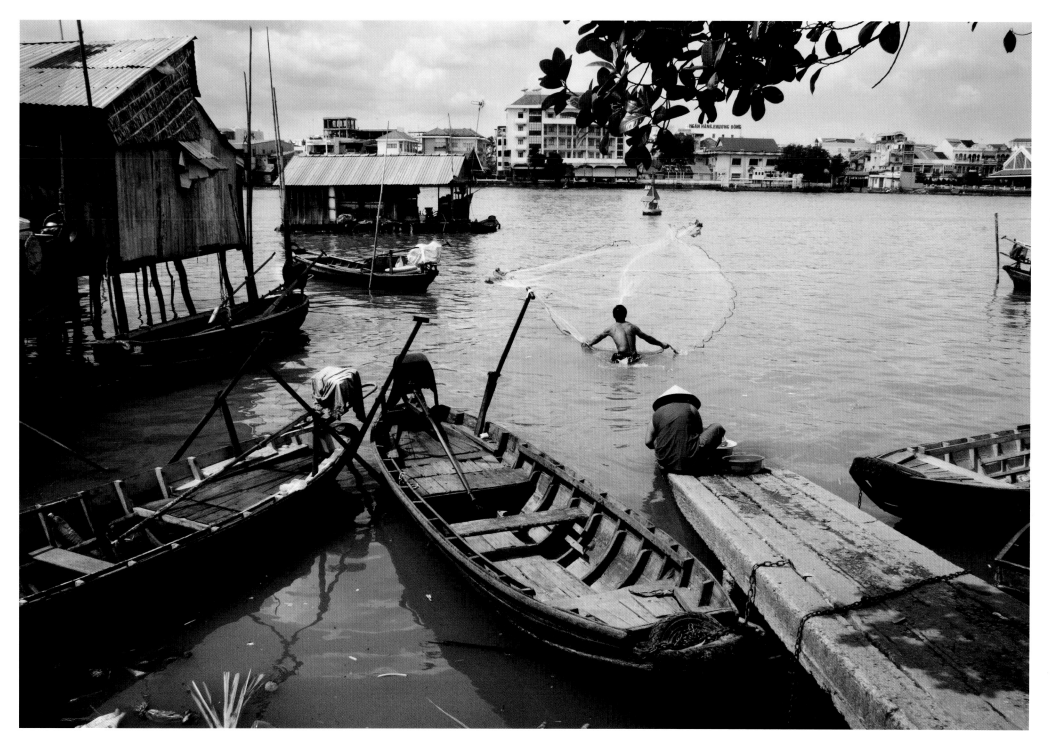

Fishing in the Mekong River, Can Tho, 2006

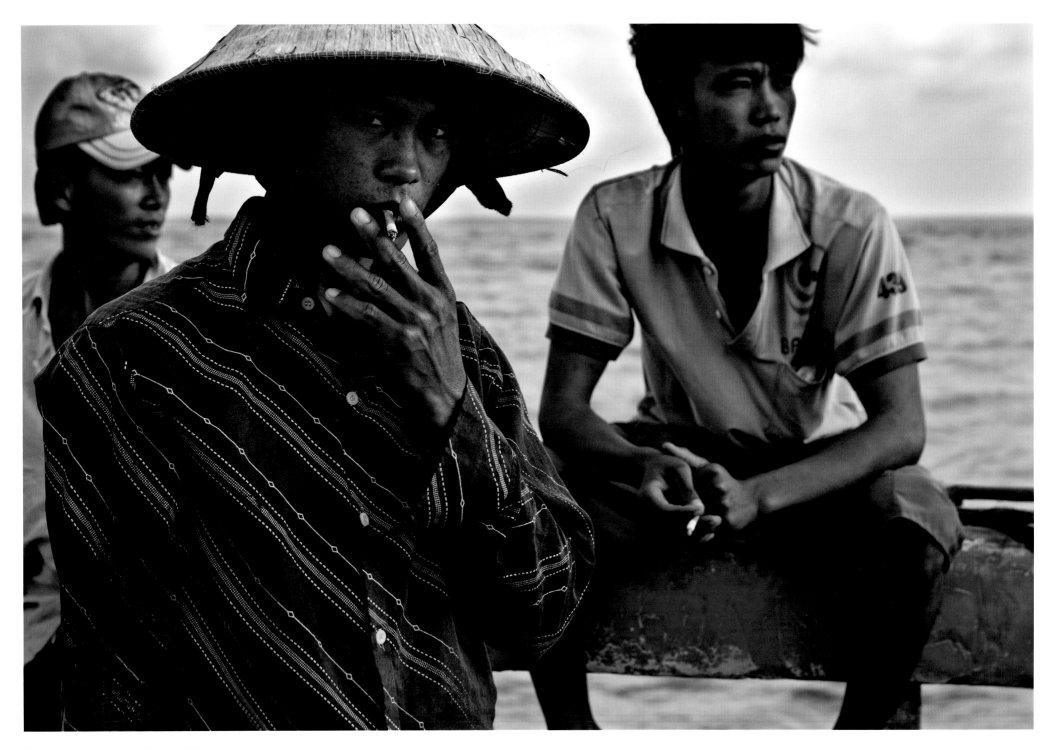

Fishermen smoking, Bac Lieu Province, 2010

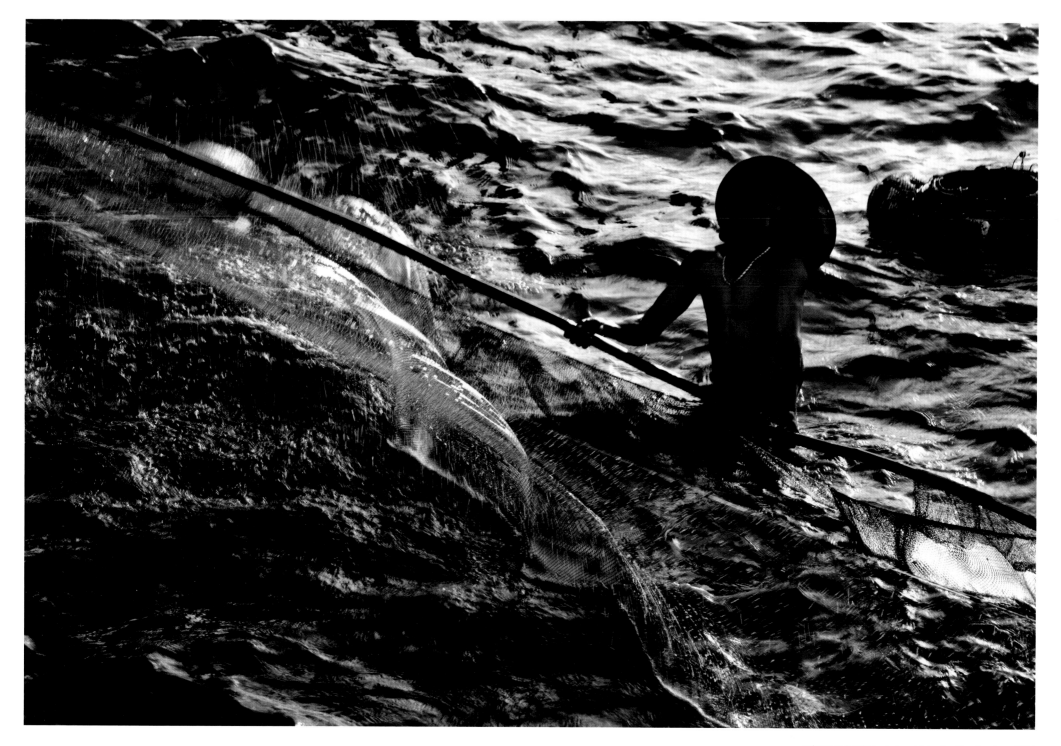

Fisherman battling wind and tide, Bac Lieu Province, 2010

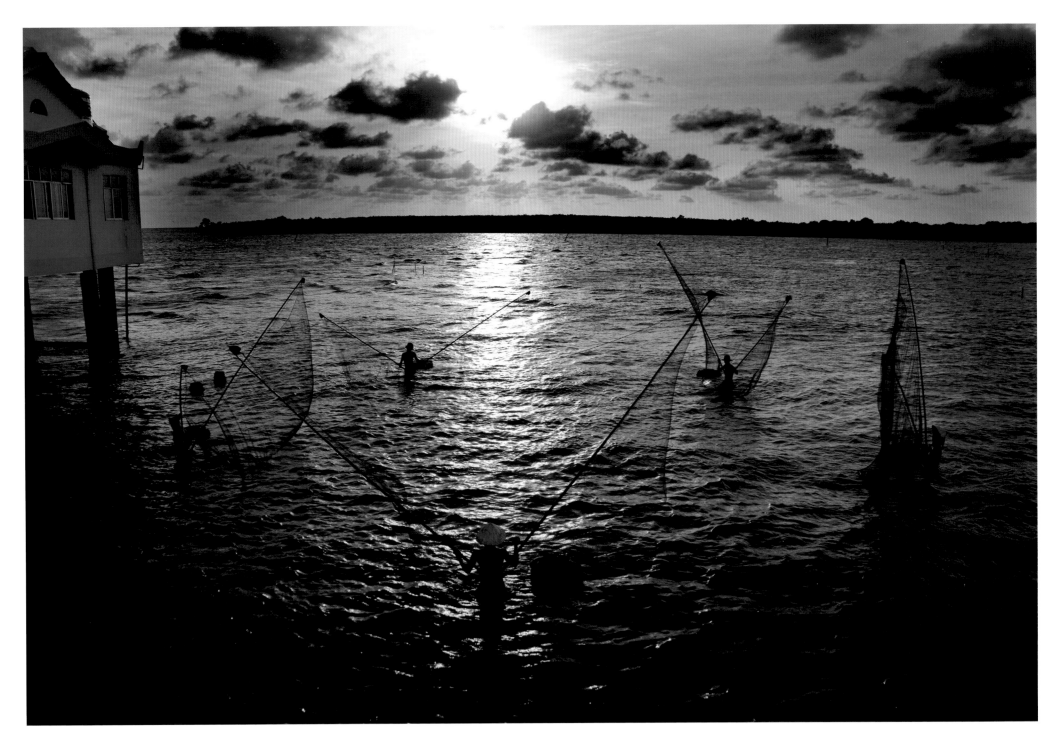

Fishing at sunset, Bac Lieu Province, 2010

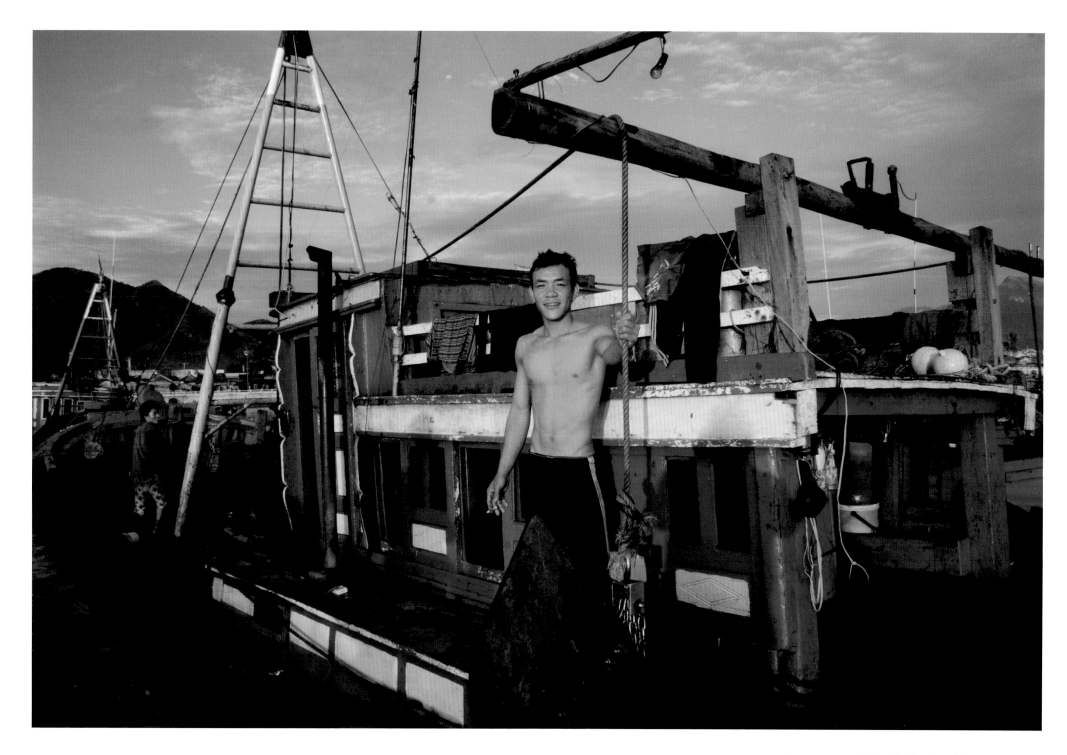

Fishermen return to harbor, Nha Trang, Khanh Koa Province, 2009

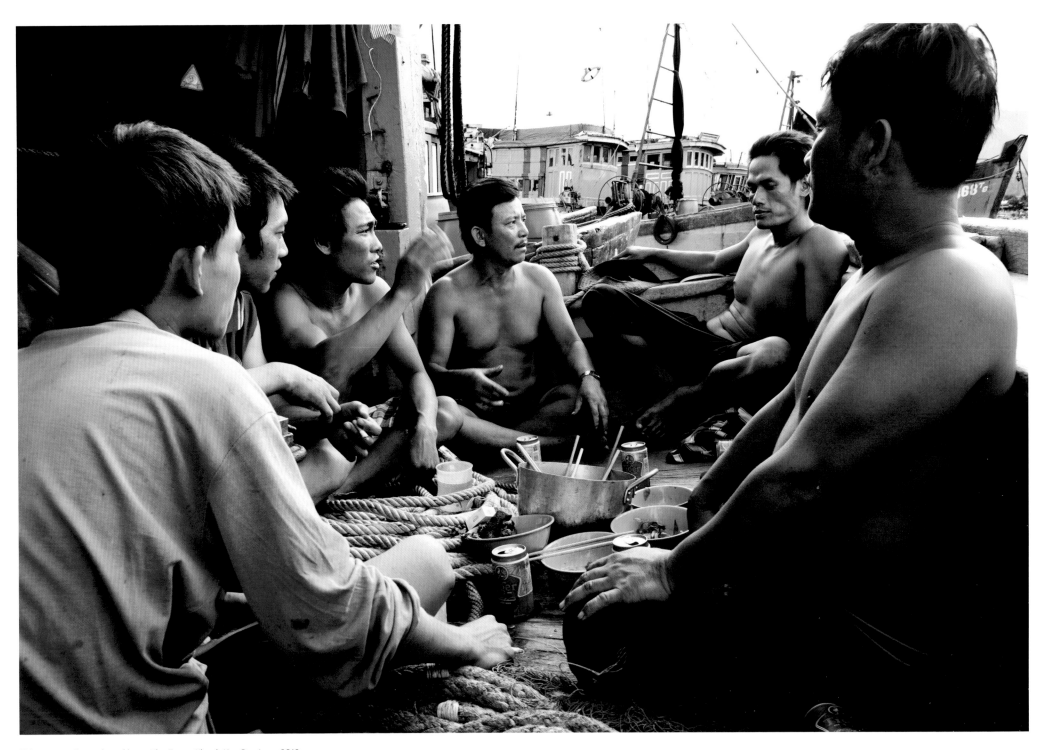

Fishermen enjoy crab and beer, Nha Trang, Khanh Koa Province, 2013

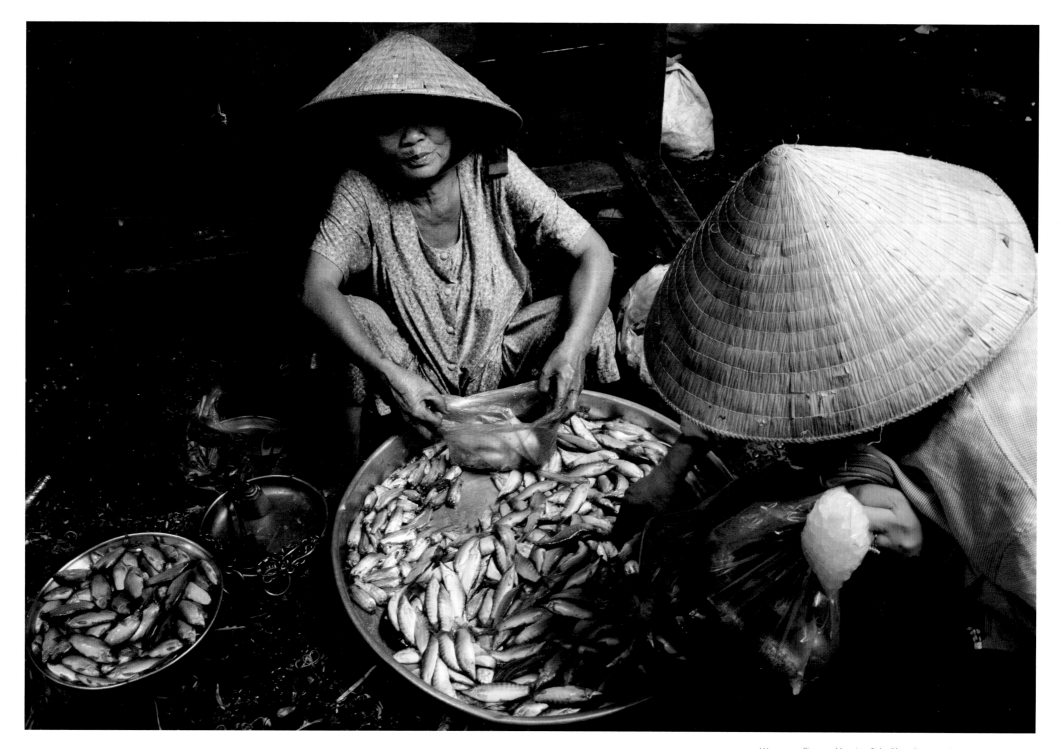

Women selling and buying fish, Chau Doc, An Giang Province, 2006

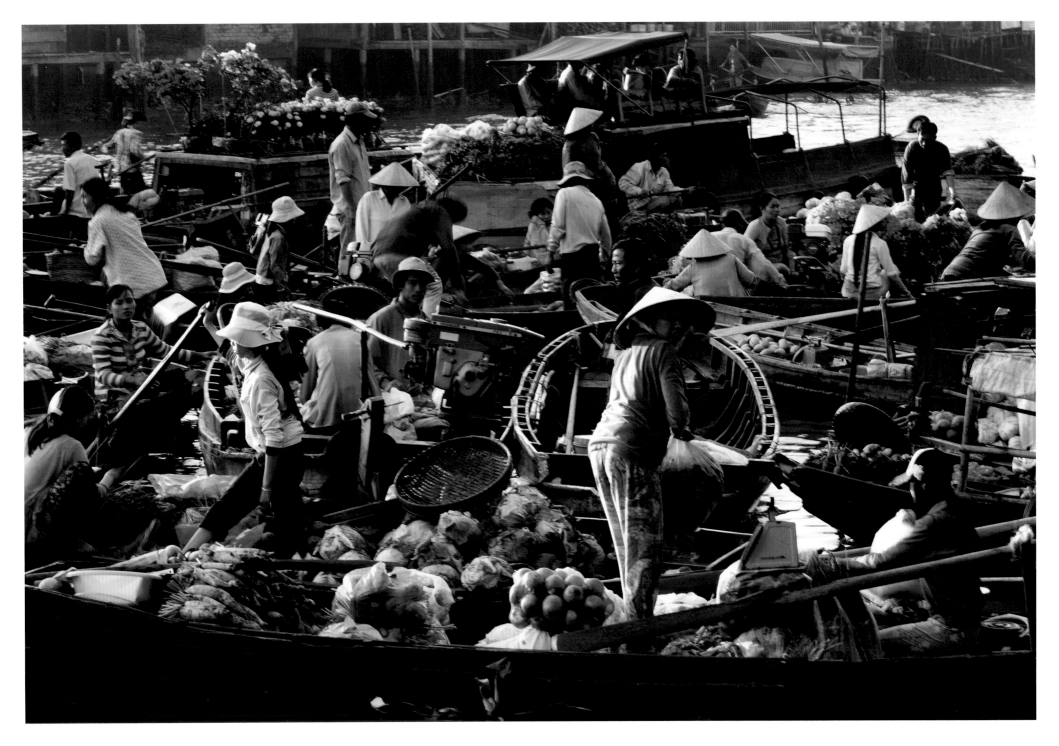

Busy morning in floating market, Phong Dien Market, Can Tho, 2010

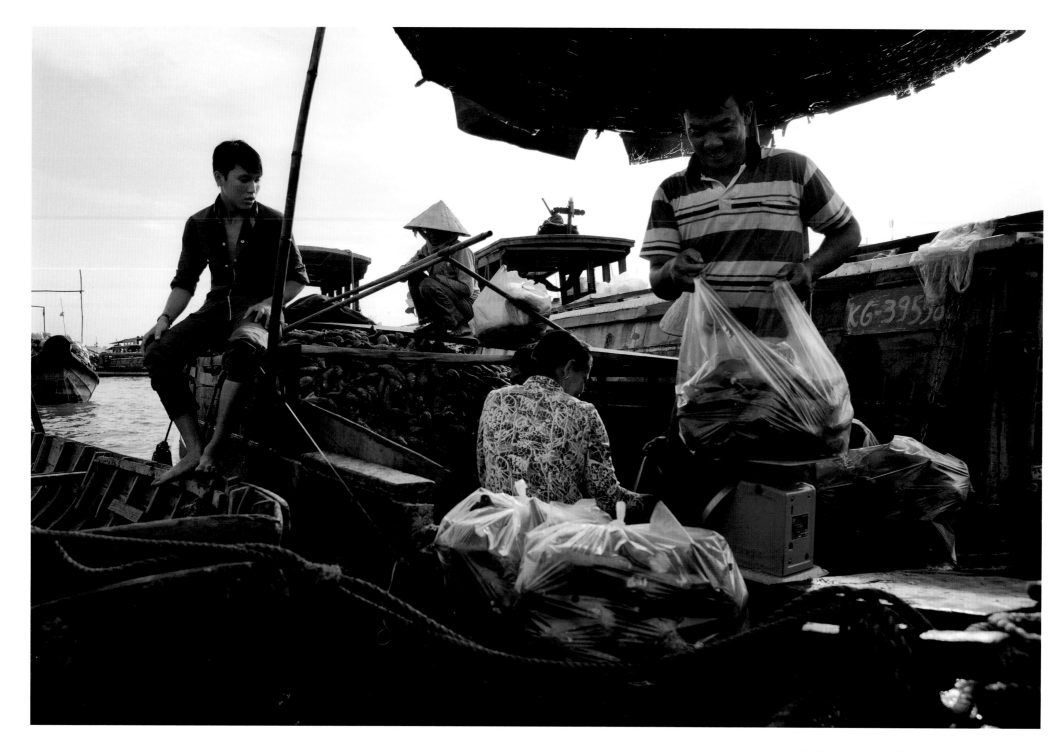

Family working on their floating market boat, Can Tho, 2013

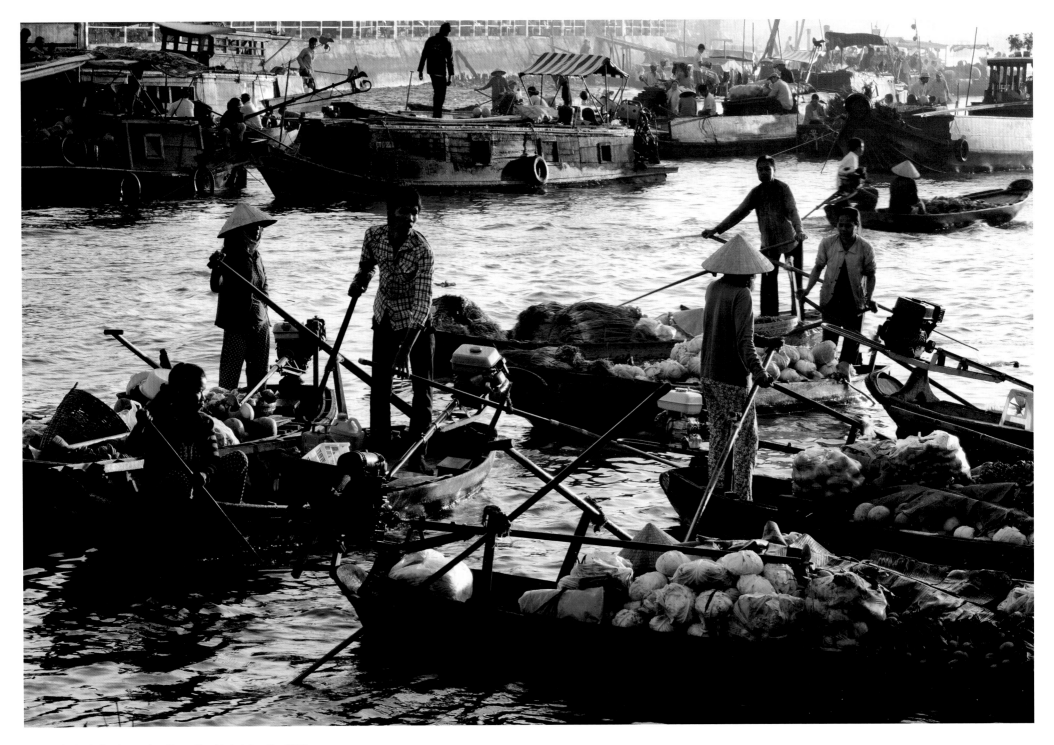

Boats gathering in floating market, Phong Dien Market, Can Tho, 2010

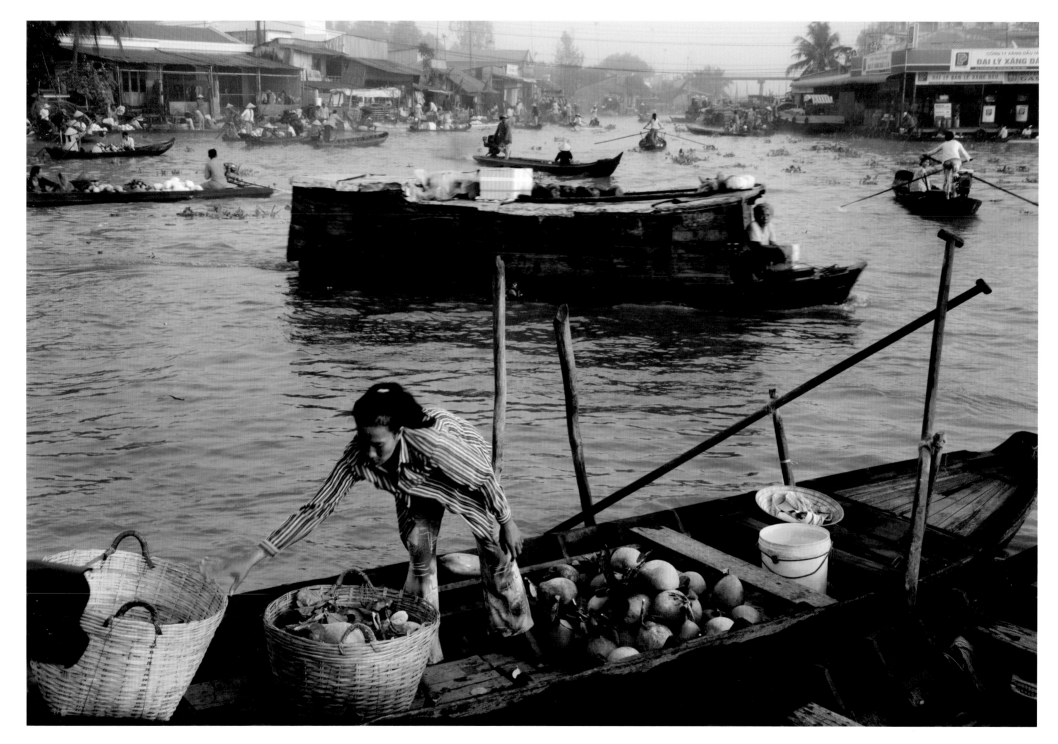

Woman readies food for sale, Nga Nam, Soc Trang Province, 2010

Boats loaded with
fruit, Cai Rang Market,
Can Tho, 2010

Young man with
chicken, Nga Nam, Soc
Trang Province, 2010

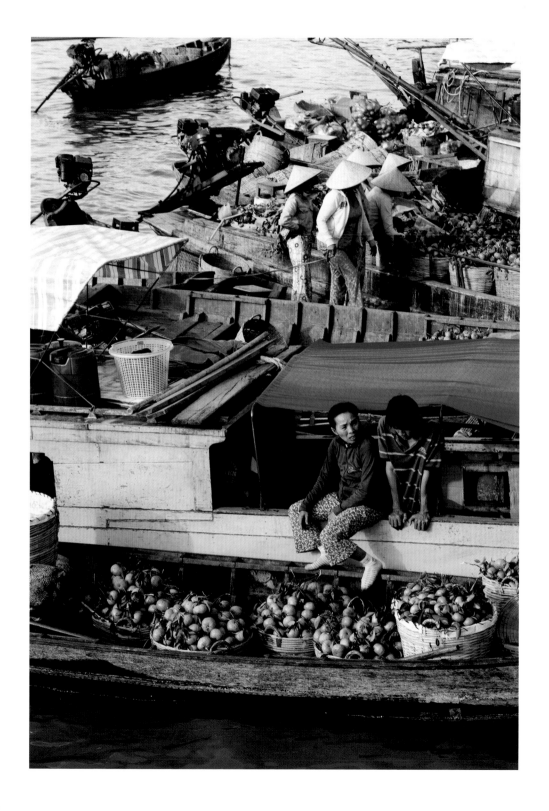
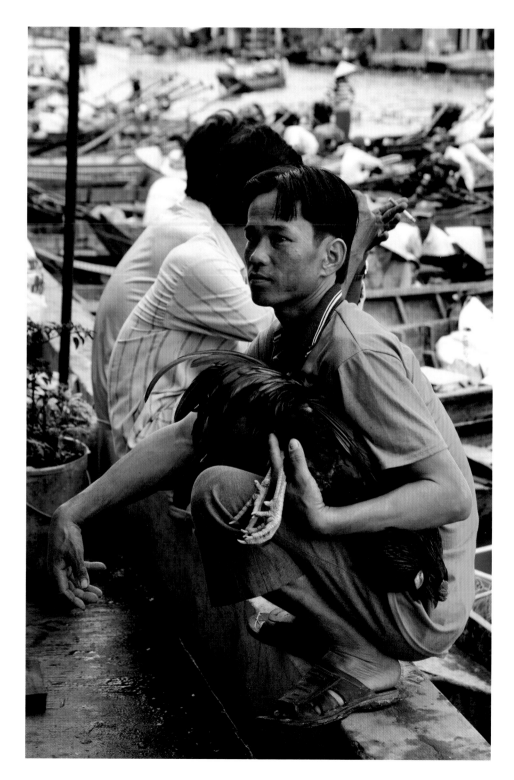

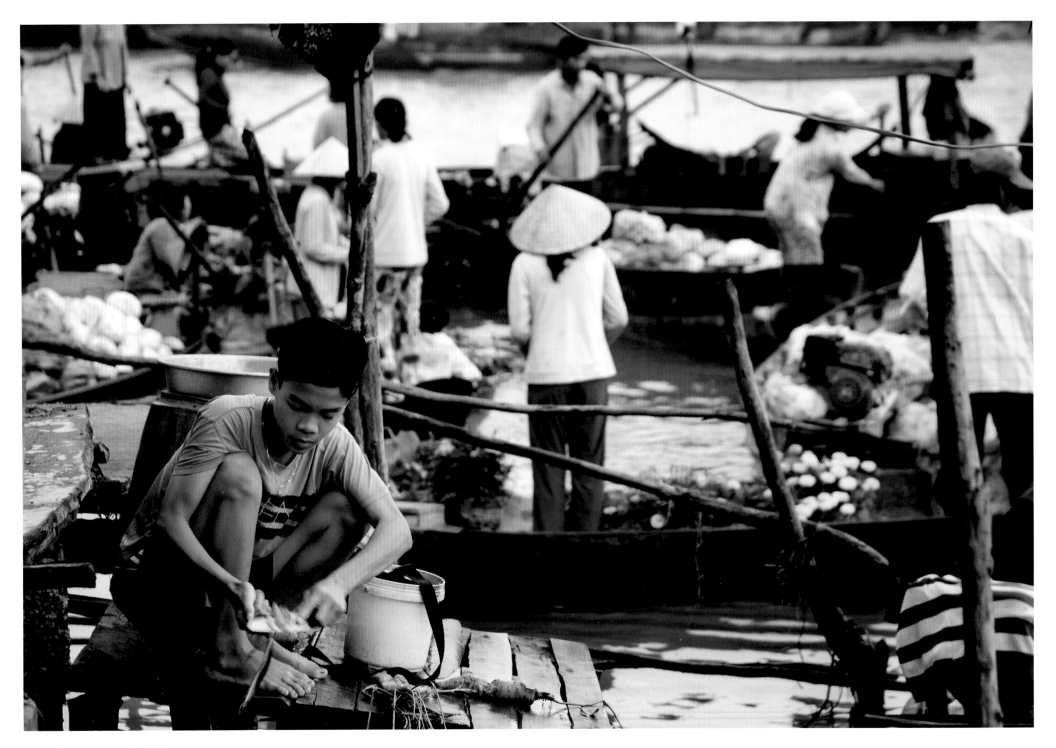

Boy peeling carrots, Can Tho, 2010

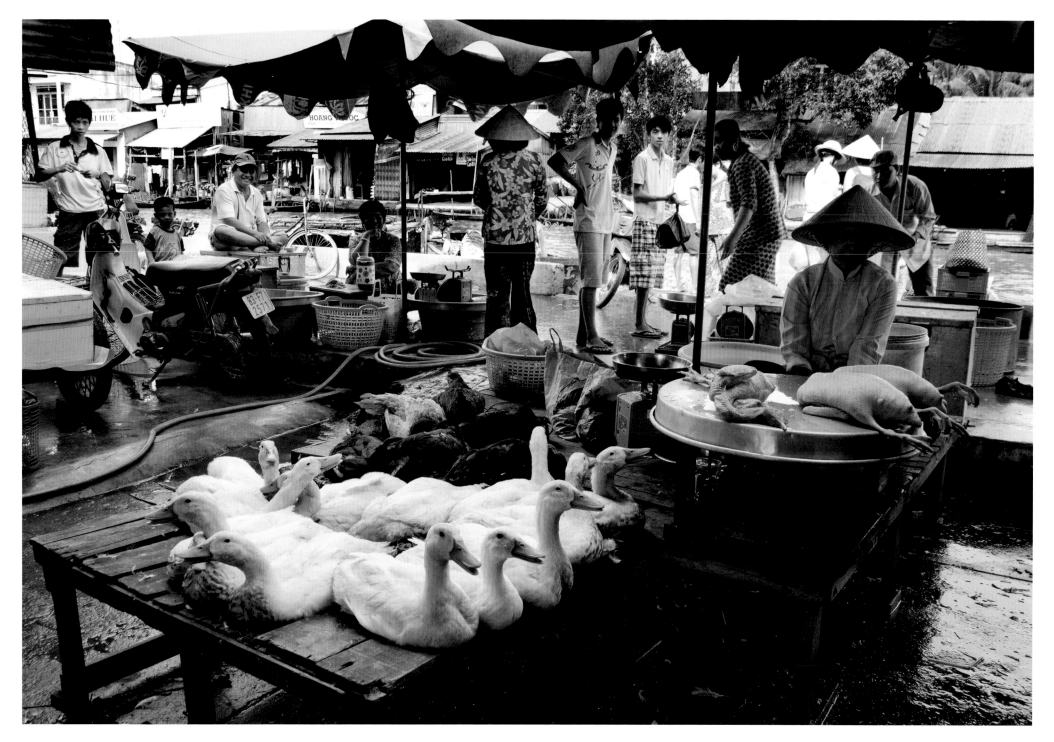

Ducks being slaughtered and dressed, Nga Nam, Soc Trang Province, 2010

The Perfume
Pagoda, Ha Tay
Province, 2006

Buddhist monk
smoking, Nga
Nam, Soc Trang
Province, 2010

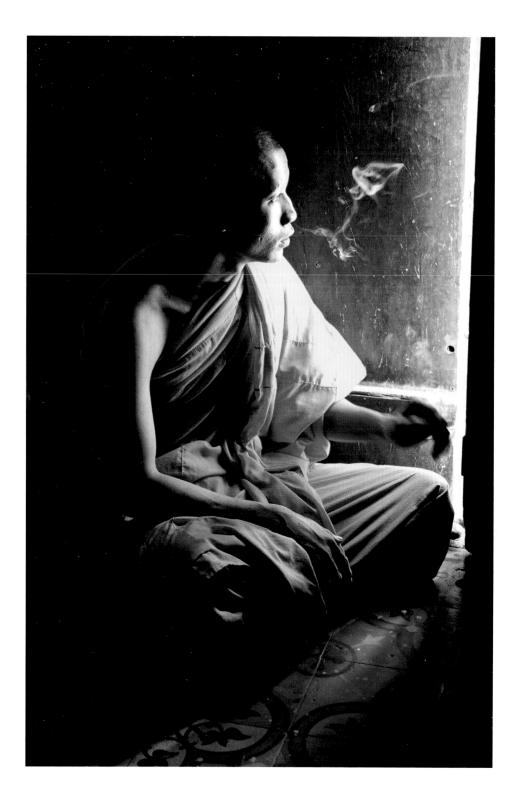

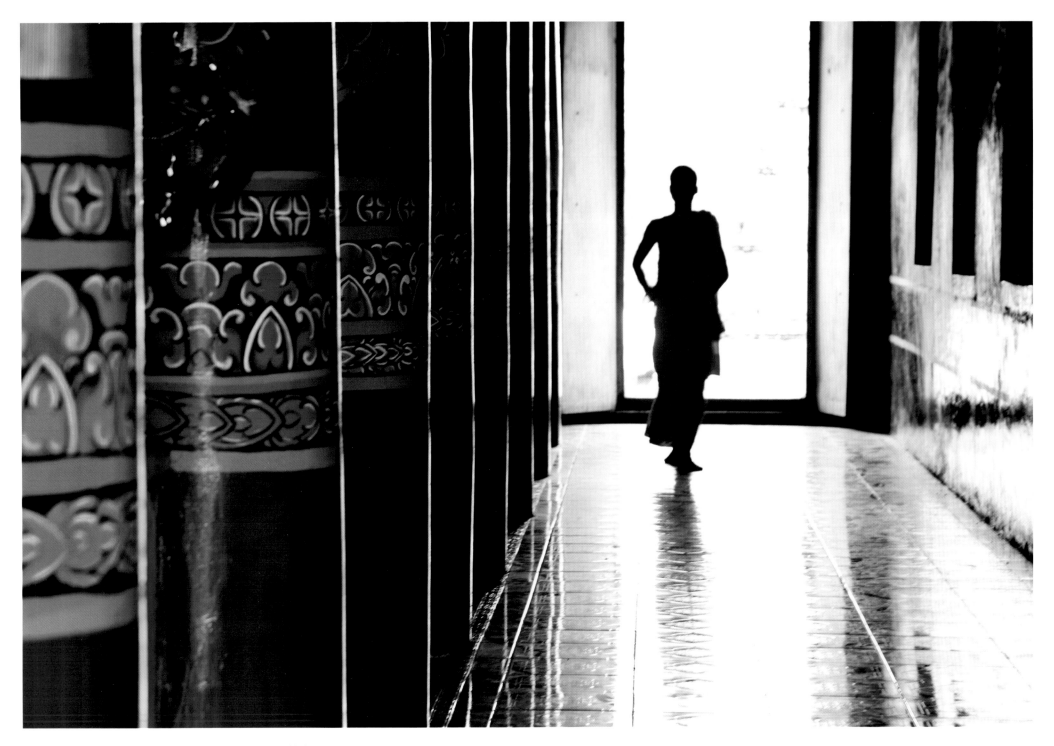

Monk walking through monastery, Nga Nam, Soc Trang Province, 2010

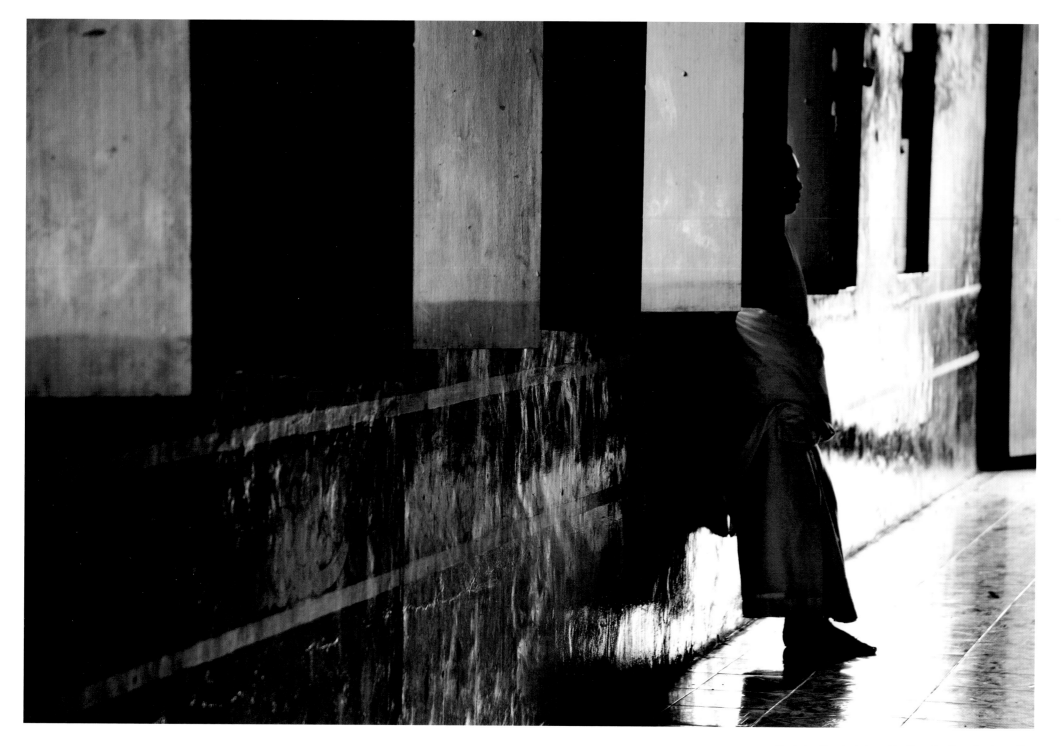

Monk standing at windows, Nga Nam, Soc Trang Province, 2010

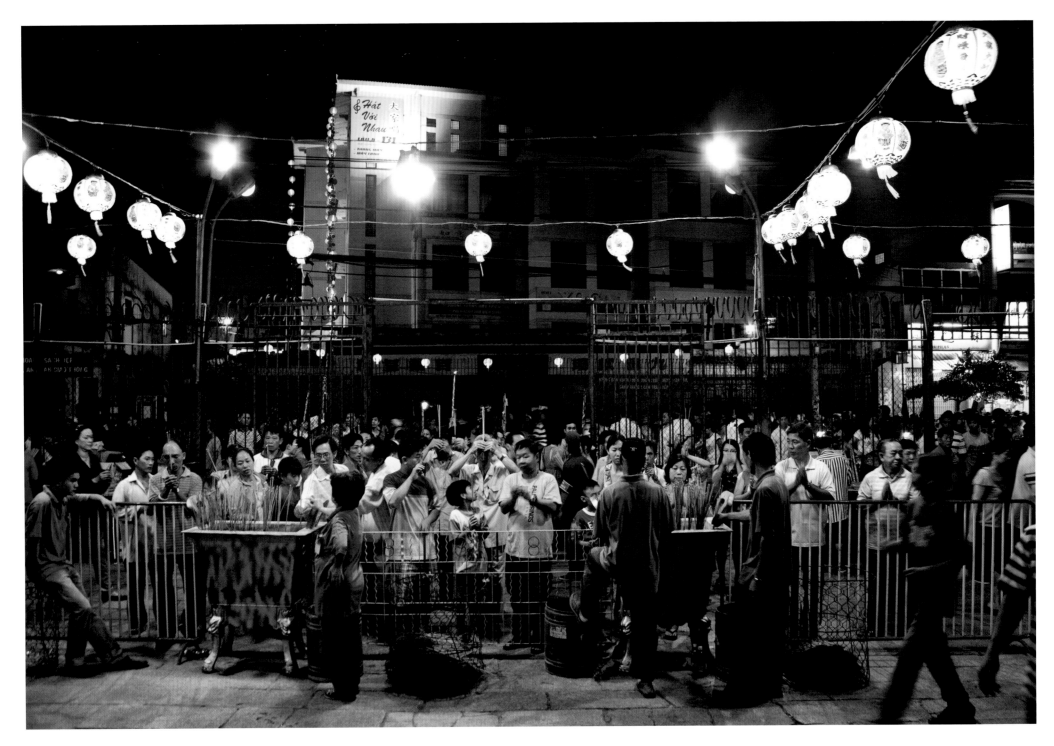

Lighting incense and praying, Chinatown, Ho Chi Minh City, 2010

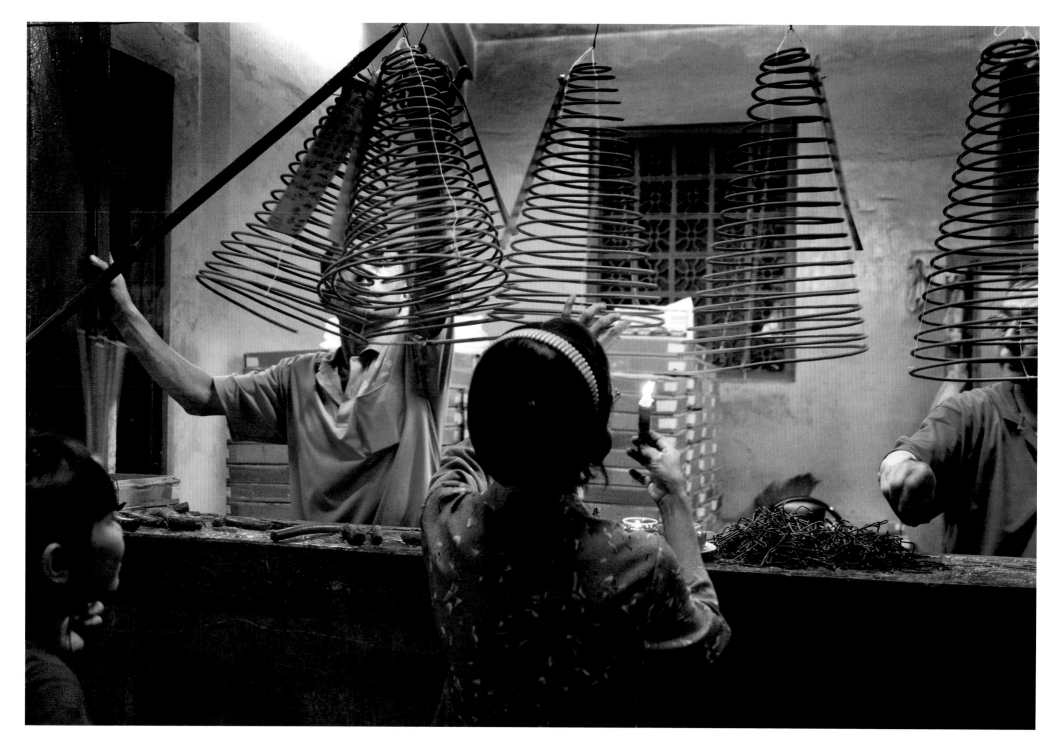

Young girl buys incense in temple, Chinatown, Ho Chi Minh City, 2010

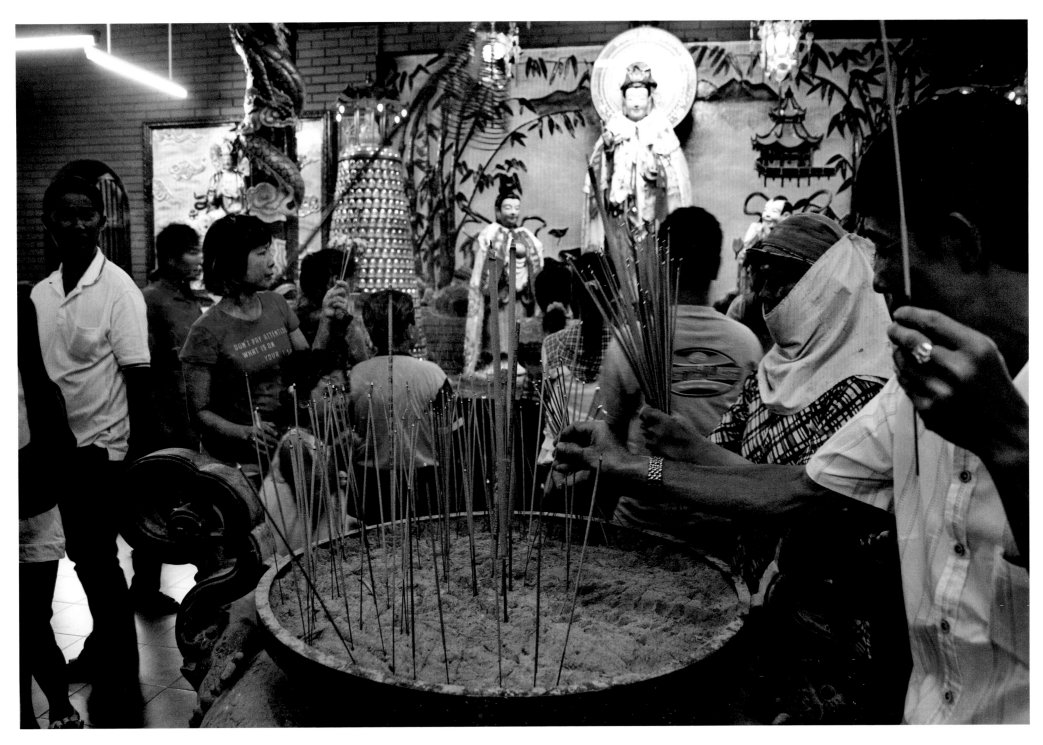

Tet celebrants light incense and pray, Chinatown, Ho Chi Minh City, 2010

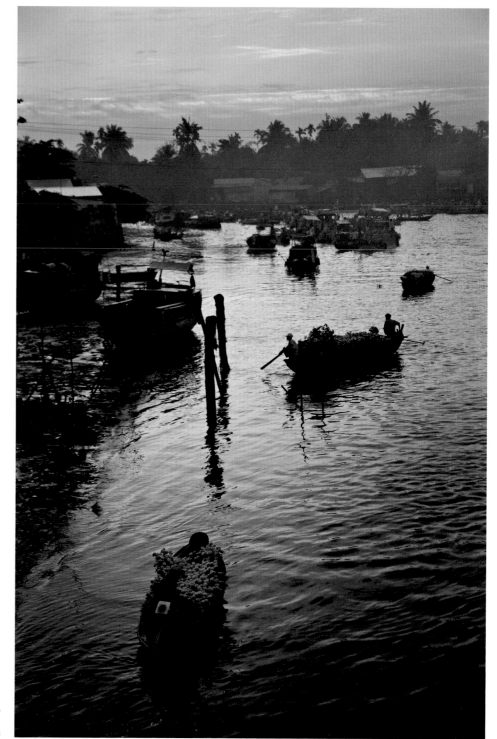

Boats laden with yellow
Tet flowers, Nga Nam,
Soc Trang Province, 2010

Taking a break
in the flower
patch, Tien Giang
Province, 2010

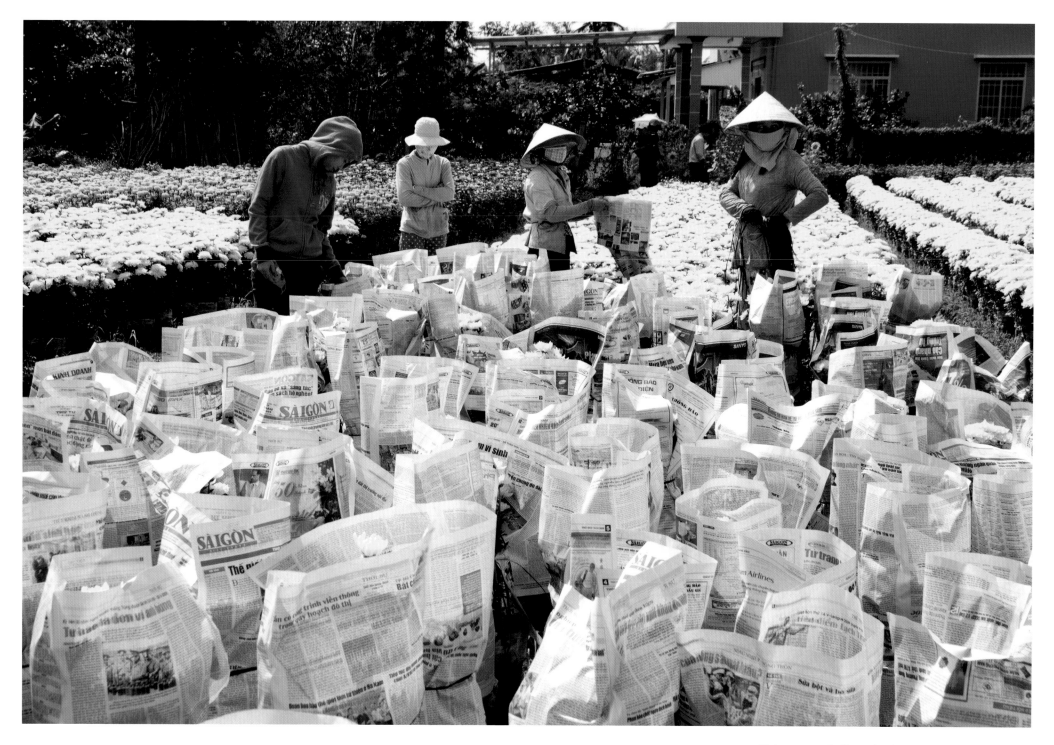

Workers prepare Tet flowers for shipping, Tien Giang Province, 2010

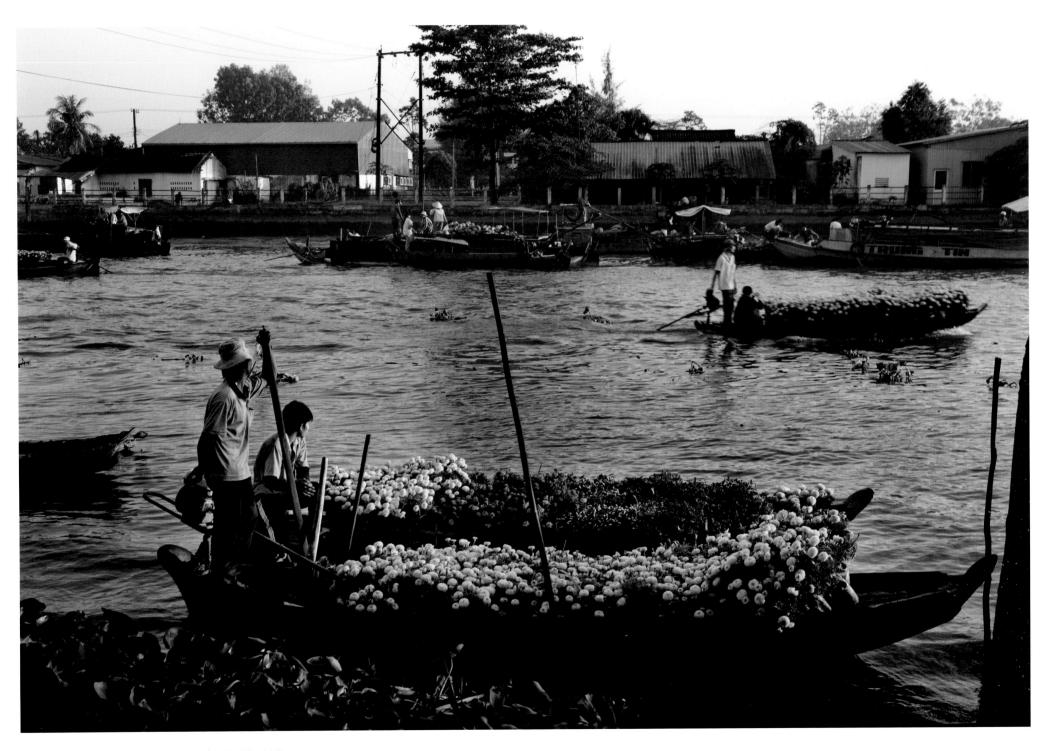

Tet flowers at floating market, Phong Dien Market, Can Tho, 2010

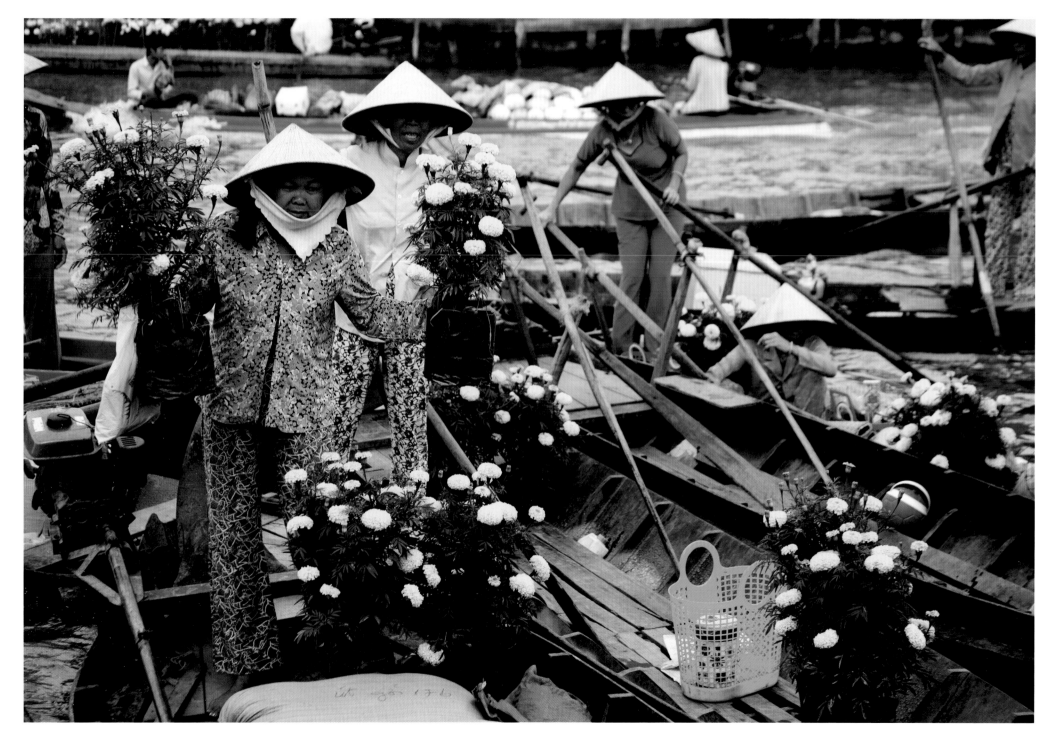

Bringing Tet flowers to market, Nga Nam, Soc Trang Province, 2010

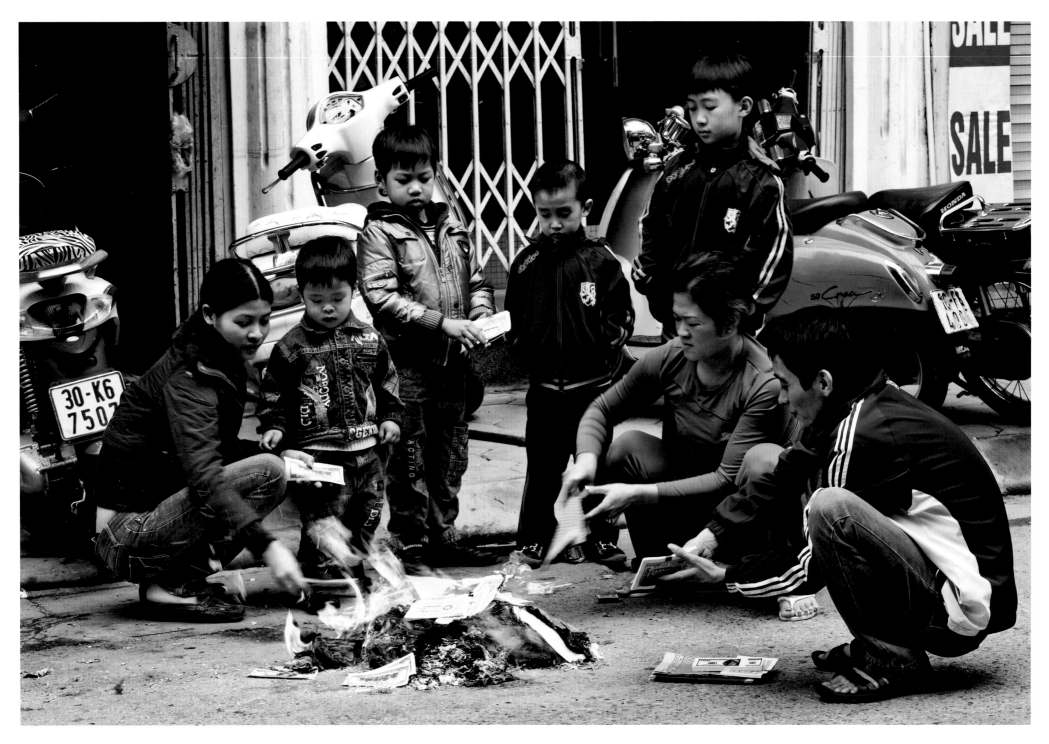

Family makes offering to ancestors, Hanoi, 2010

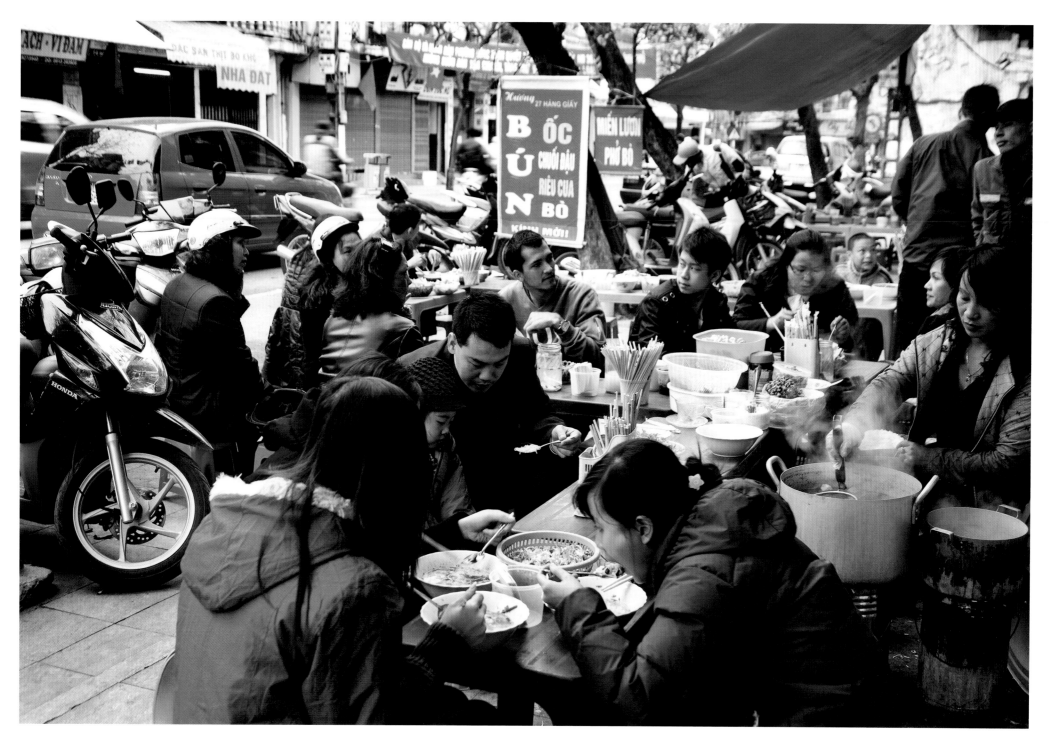

Tet celebrated with meals, Hanoi, 2010

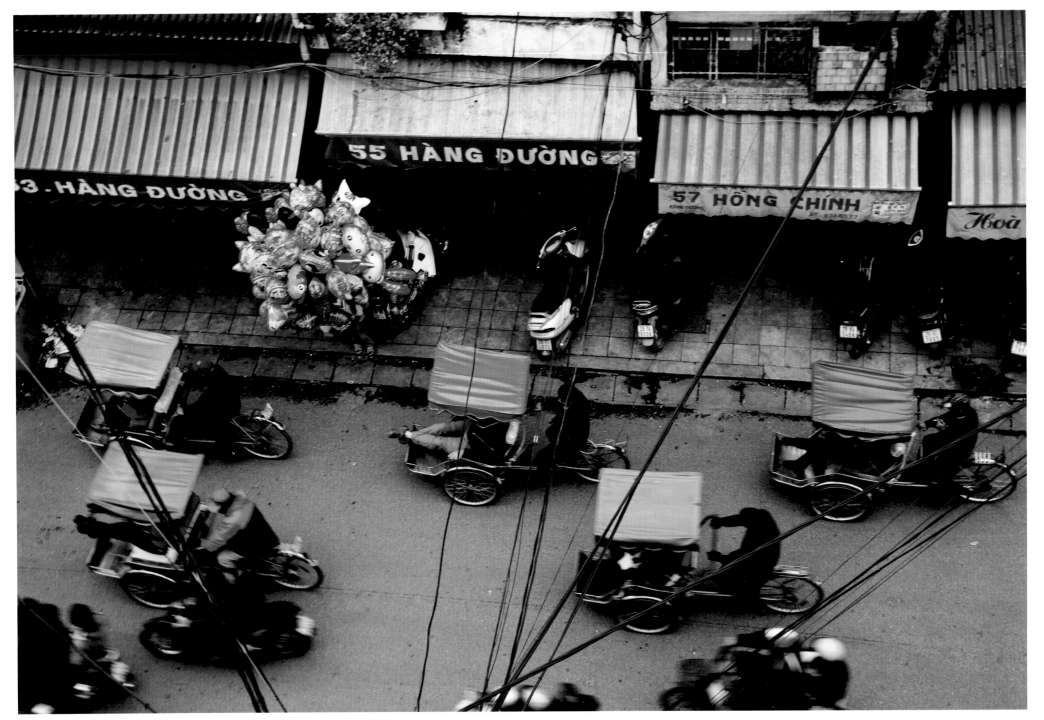

Touring the city during Tet, Hanoi, 2010

Dressed-up at the park for Tet, Hanoi, 2010

Balloon salesman during Tet, Hanoi, 2010

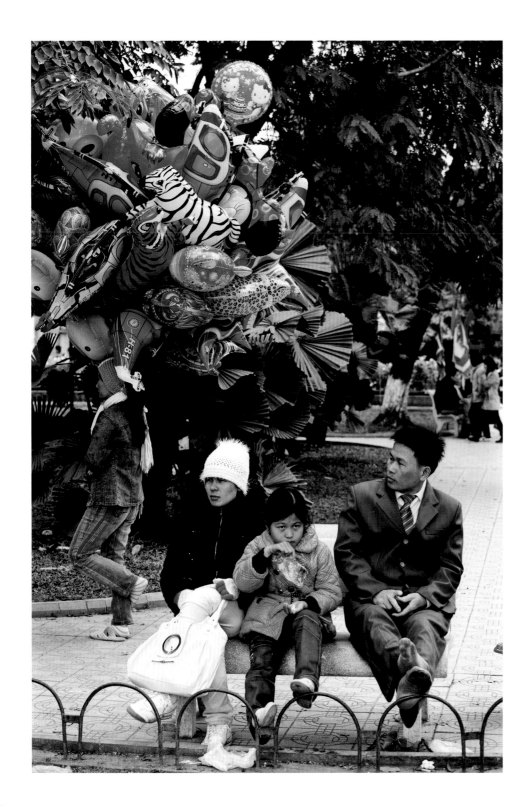
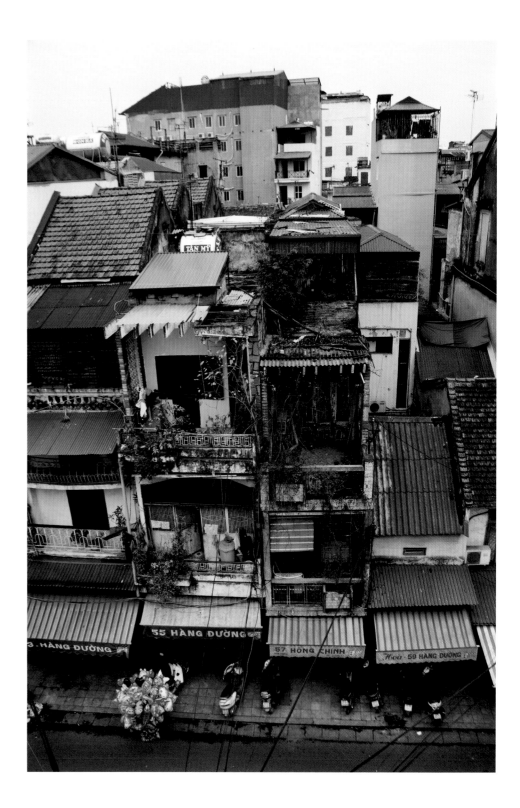

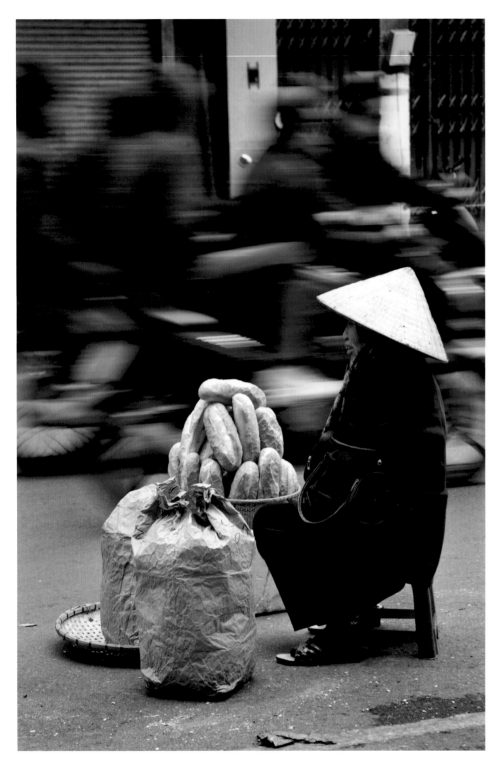

Woman selling
baguettes,
Hanoi, 2010

Women selling bread,
Hanoi, 2010

Working class
home, Hanoi, 2005

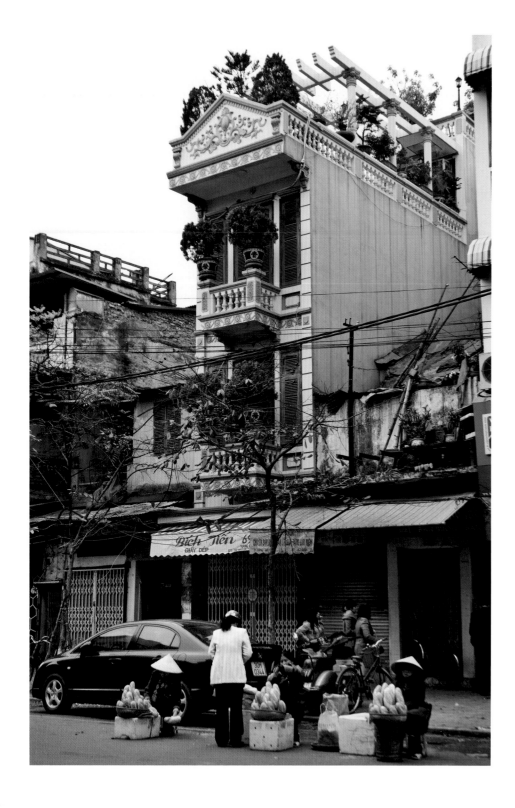

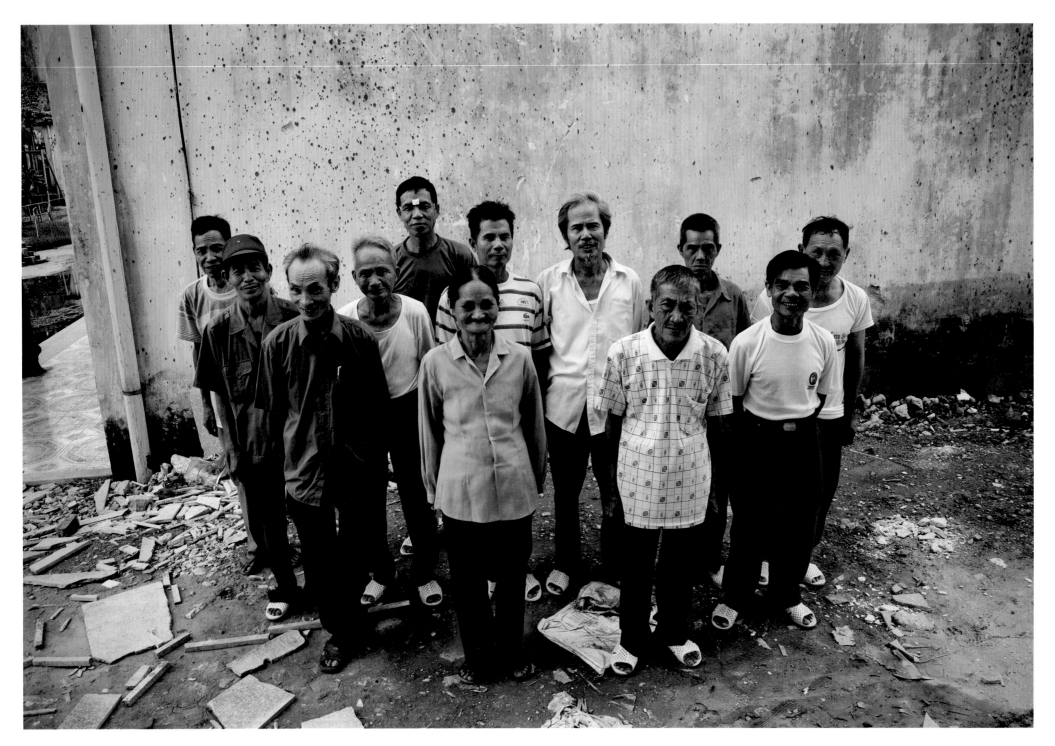

North Vietnam war veterans, Hanoi, 2011

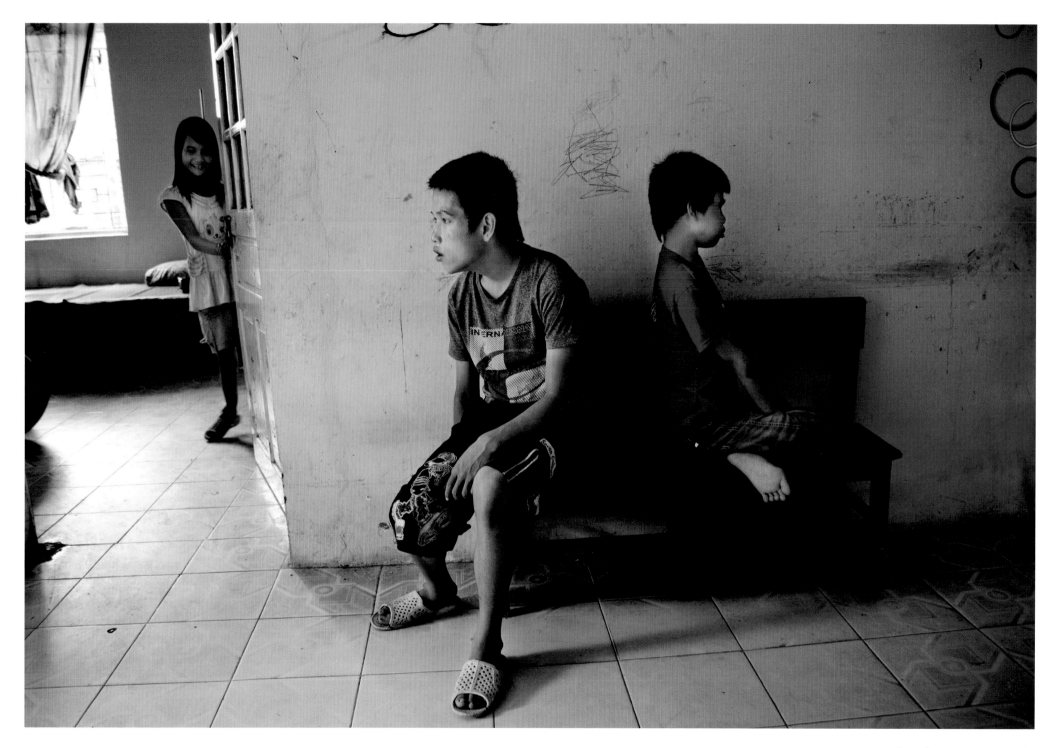

Agent Orange victims, Hanoi, 2011

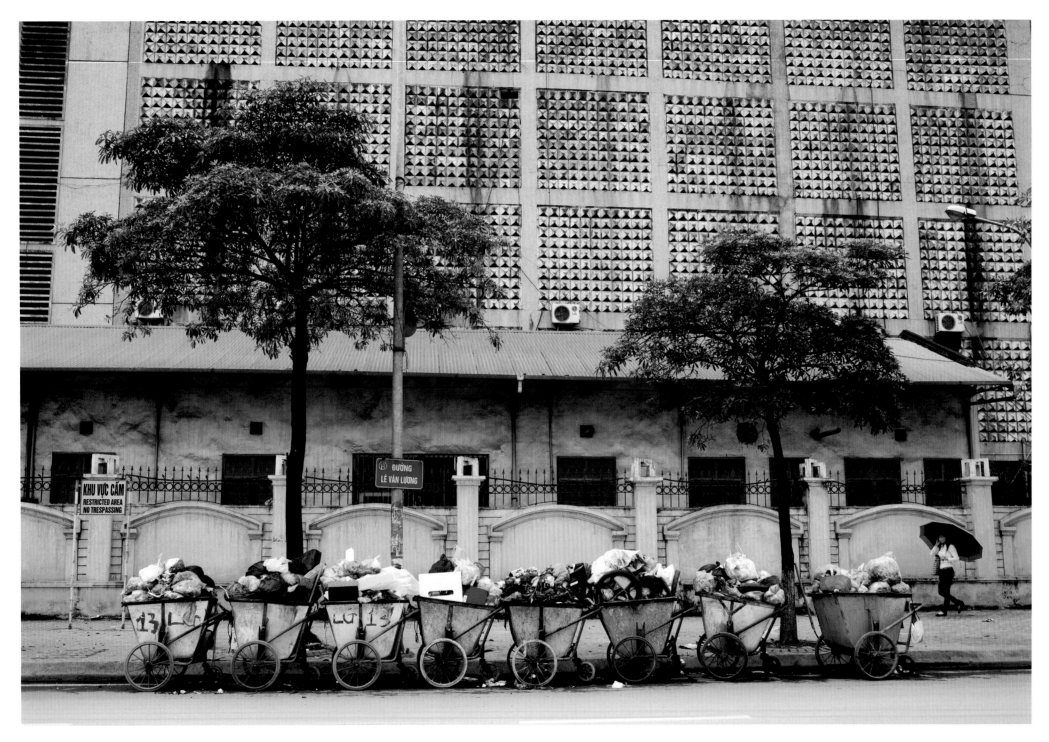

Full trash bins on street, Hanoi, 2011

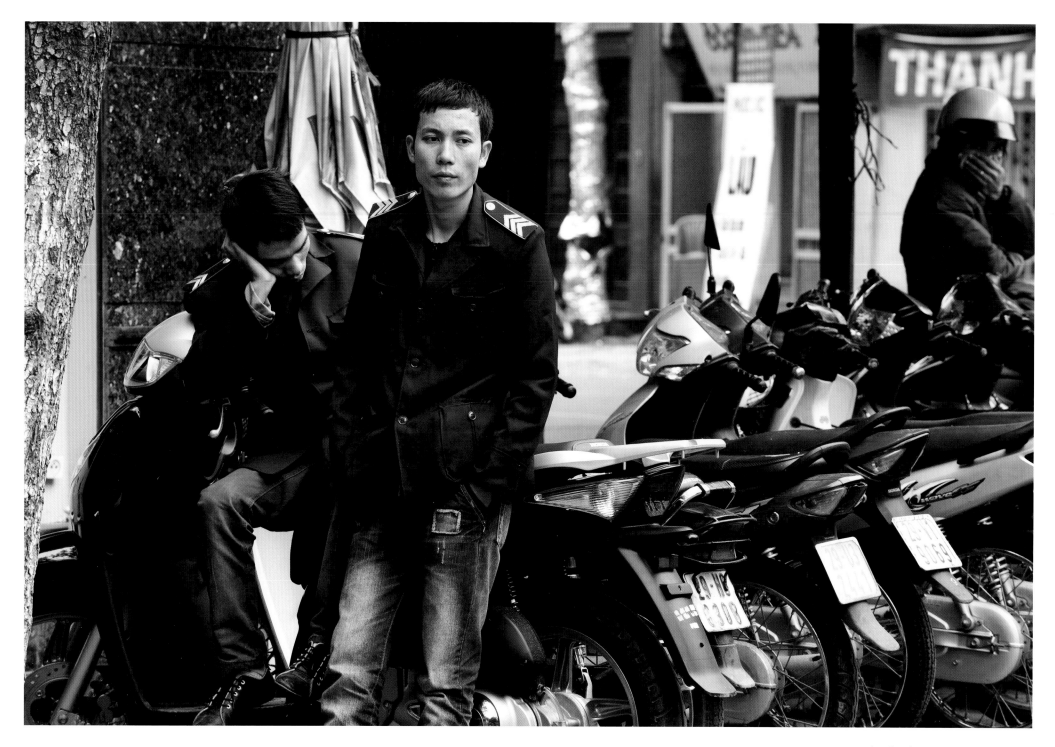

Railroad workers passing time, Hanoi, 2010

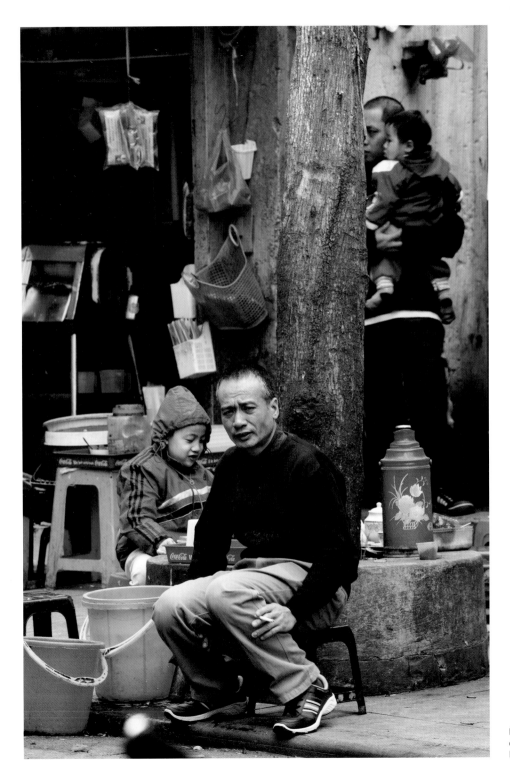

Fathers with
children,
Hanoi, 2010

Tire repairman reading,
Hanoi, 2010

Senior eating mango,
Ho Chi Minh City, 2009

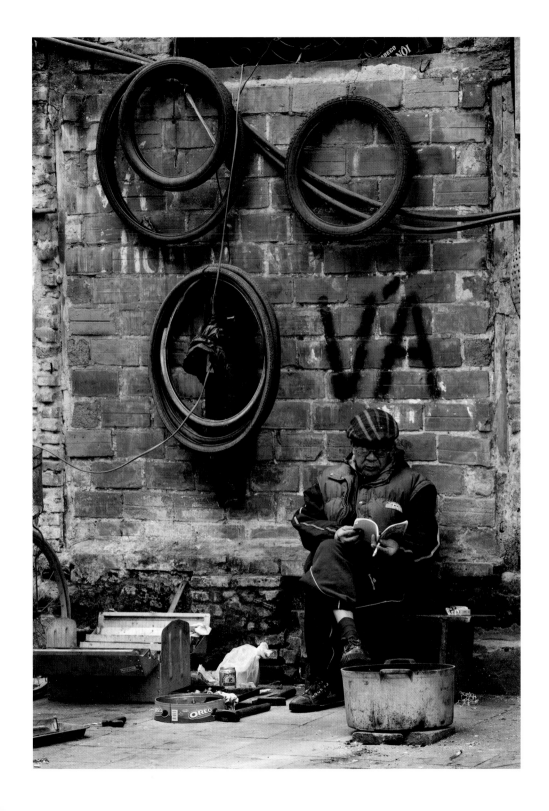
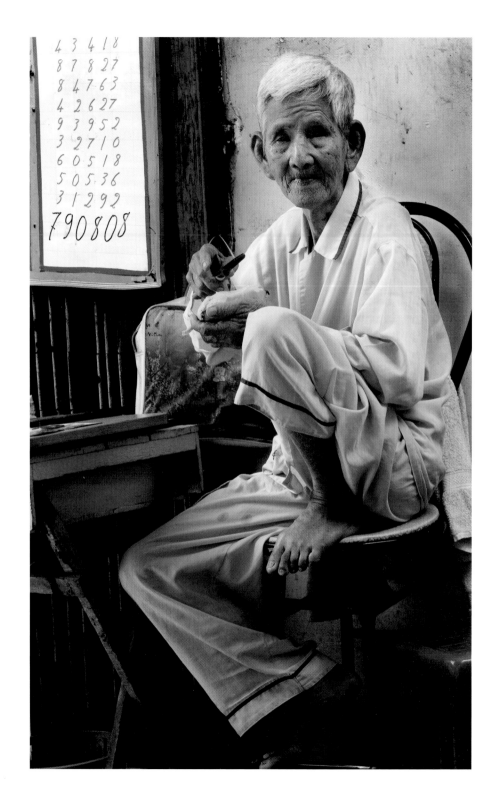

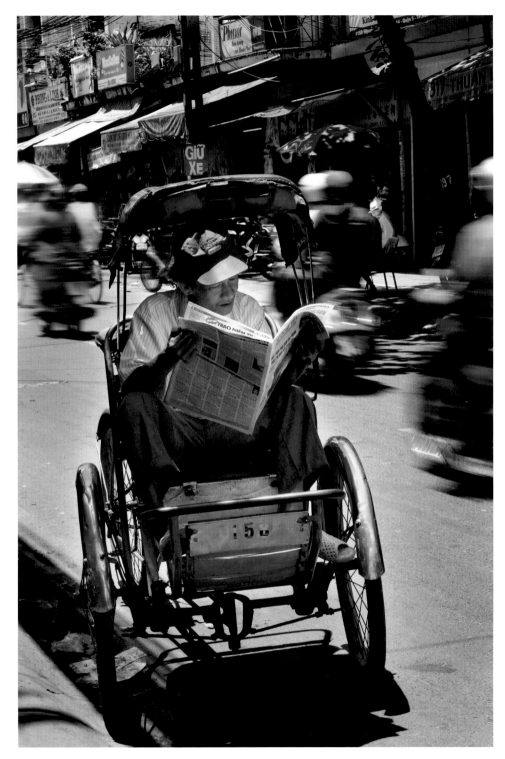

Cyclo driver reading
newspaper, Ho Chi
Minh City, 2009

Young and old, Hanoi, 2010

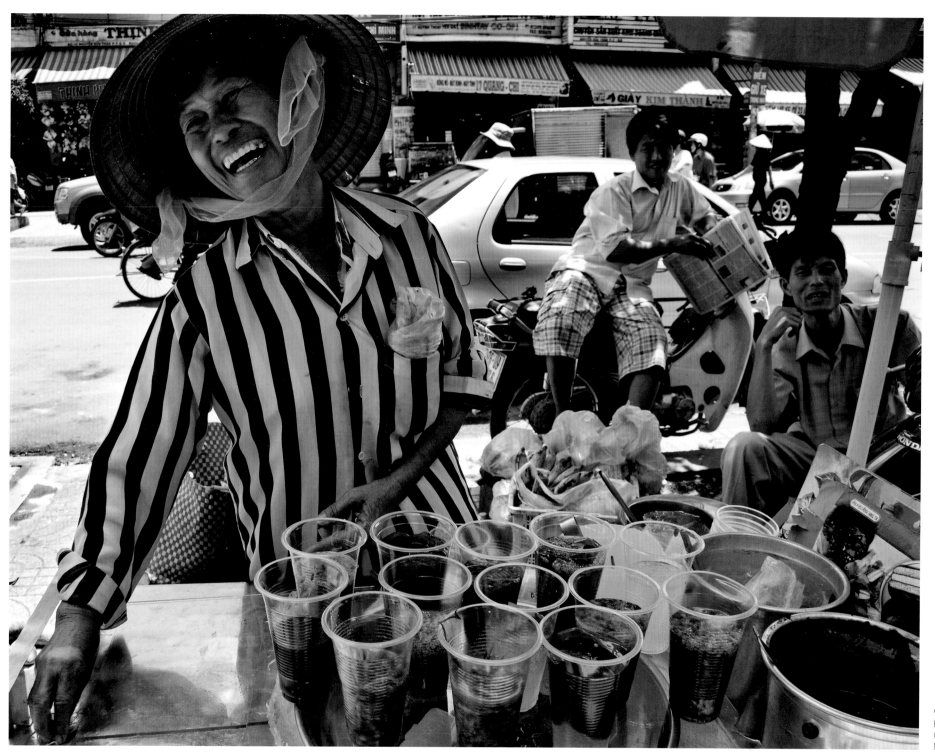

Woman making
herbal drinks,
Chinatown, Ho Chi
Minh City, 2010

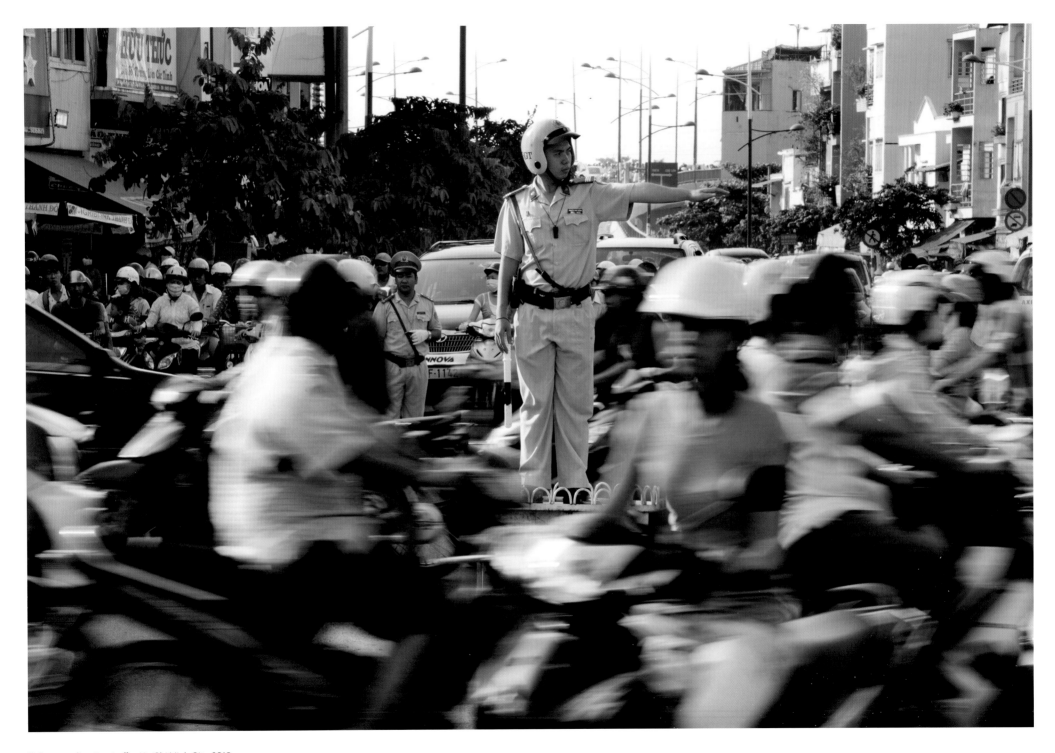

Policeman directing traffic, Ho Chi Minh City, 2010

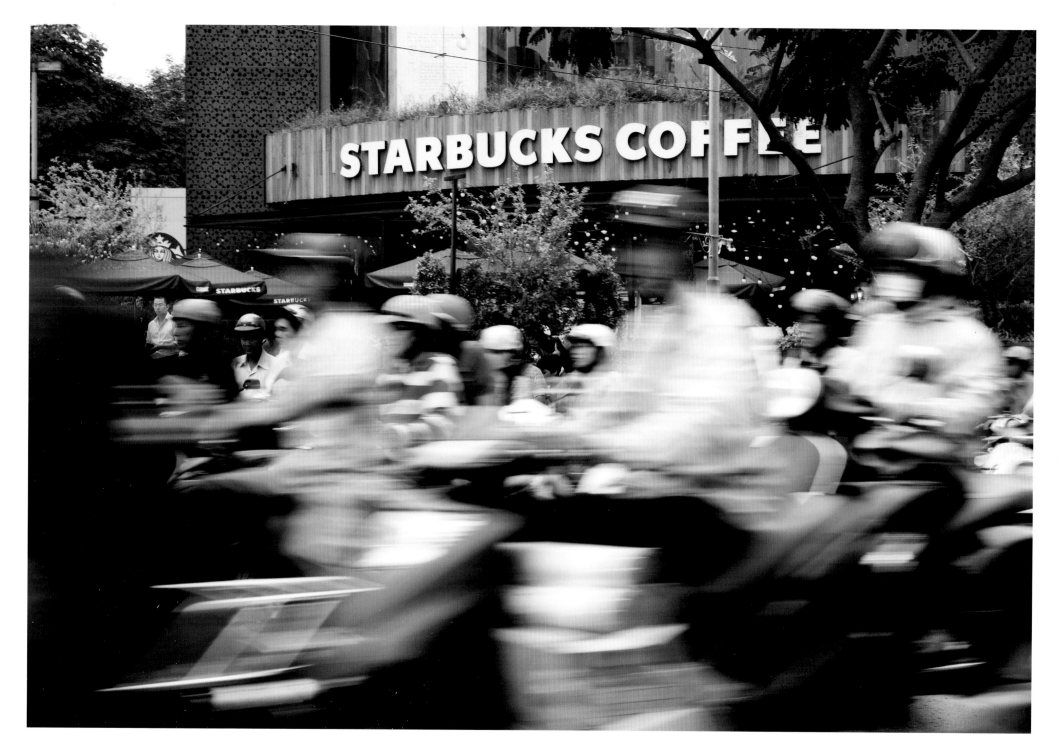

Starbucks opens first store, Ho Chi Minh City, 2013

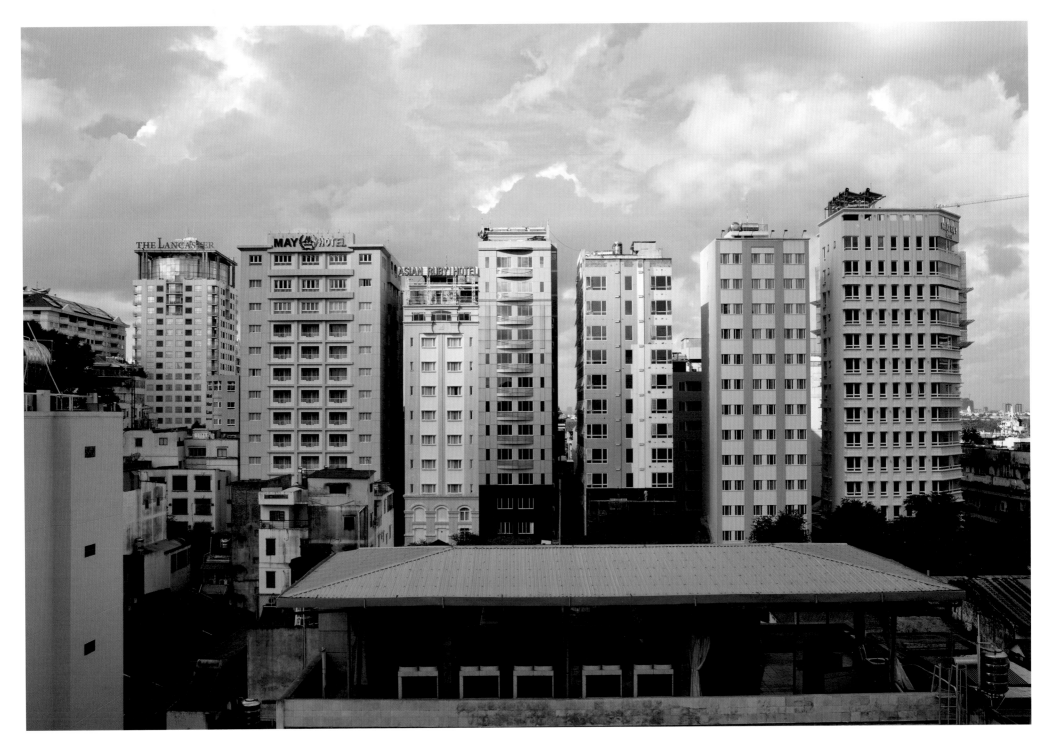

Hotels under building monsoon, Ho Chi Minh City, 2011

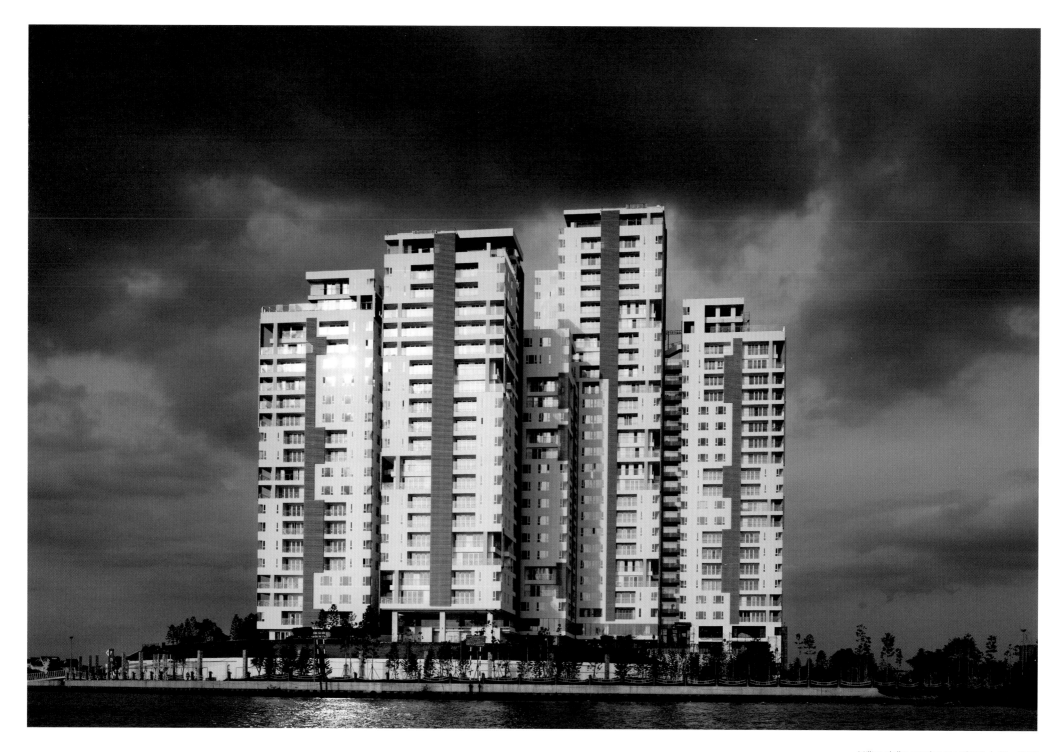

Million dollar condos, Ho Chi Minh City, 2013

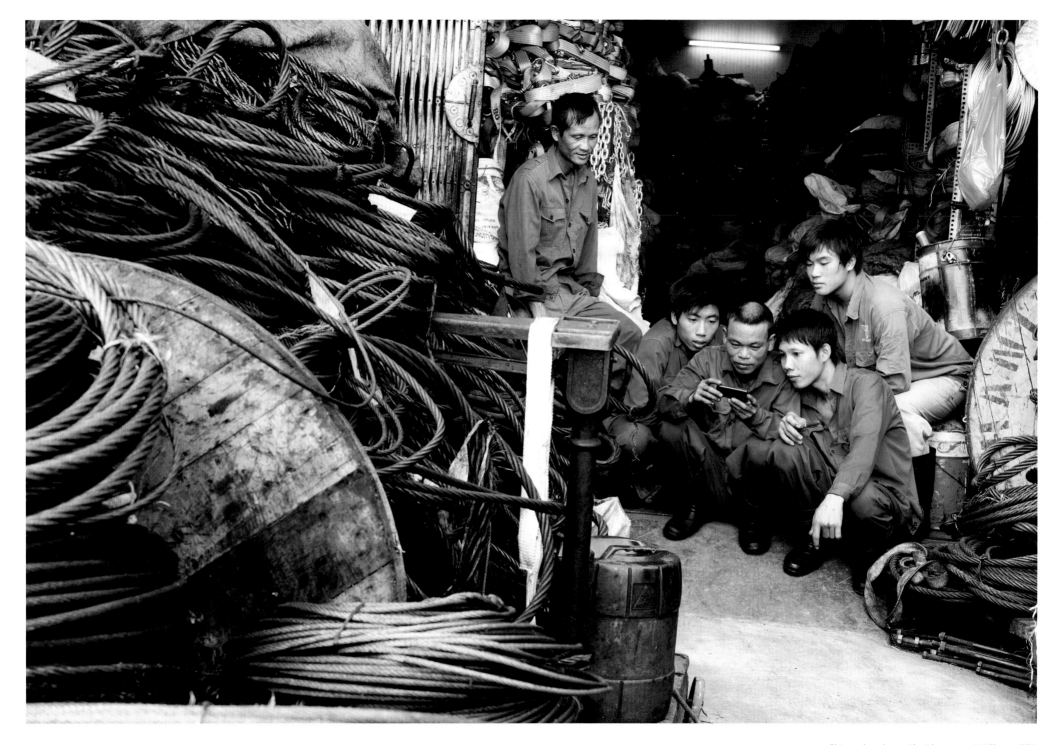

Shipyard workers with video game, Hai Phong, 2011

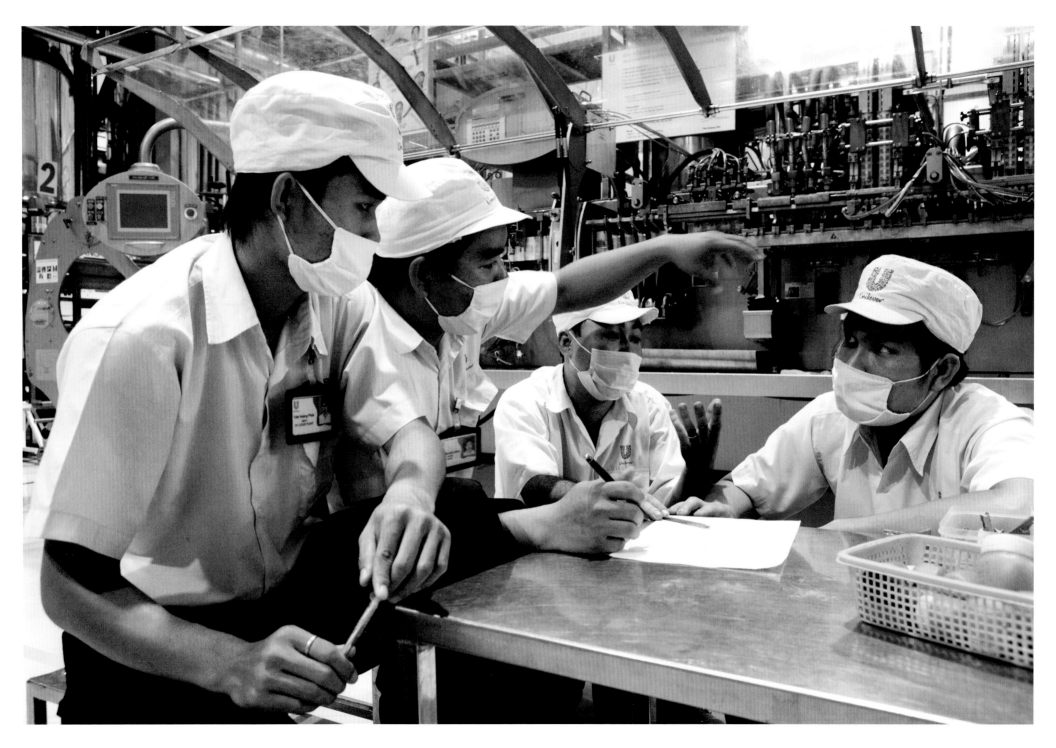

Unilever workers solving problem, Ho Chi Minh City, 2012

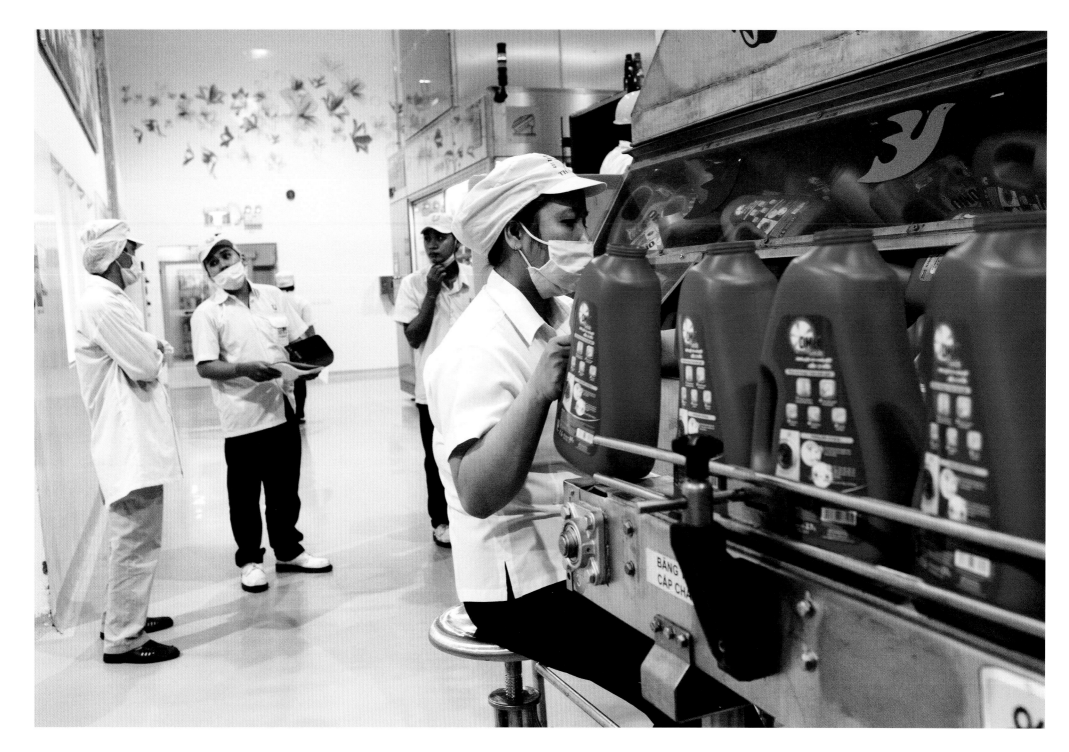

Unilever production line, Ho Chi Minh City, 2012

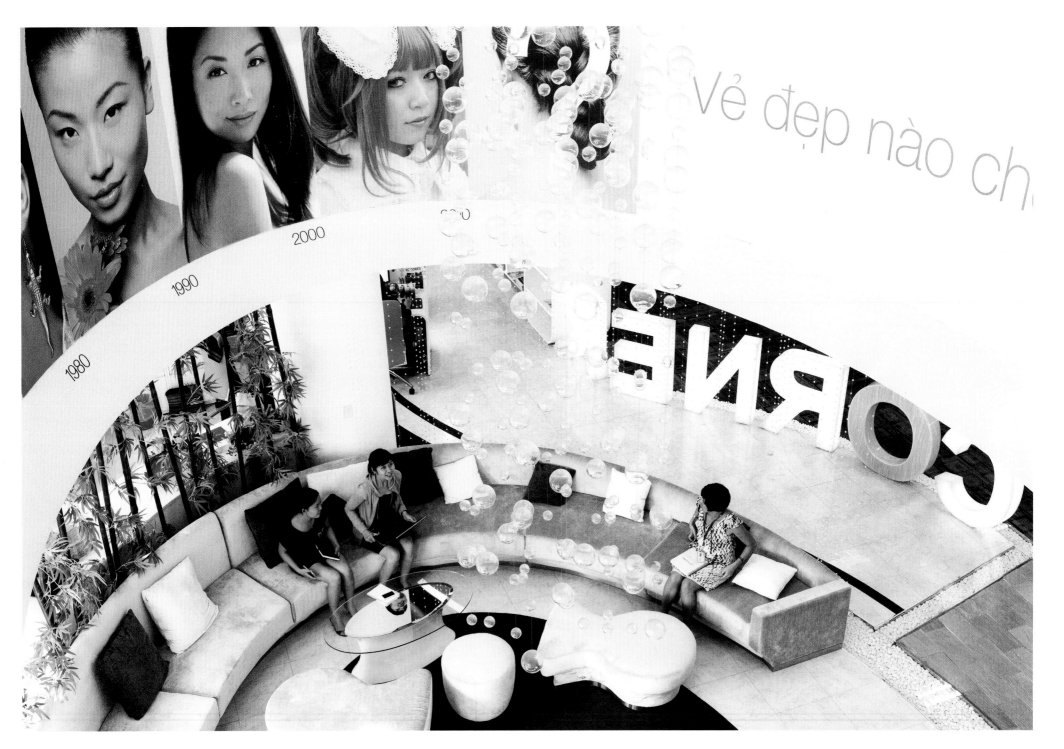

vẻ đẹp nào ch...

1980 1990 2000 ...

Modern Unilever headquarters, Ho Chi Minh City, 2012

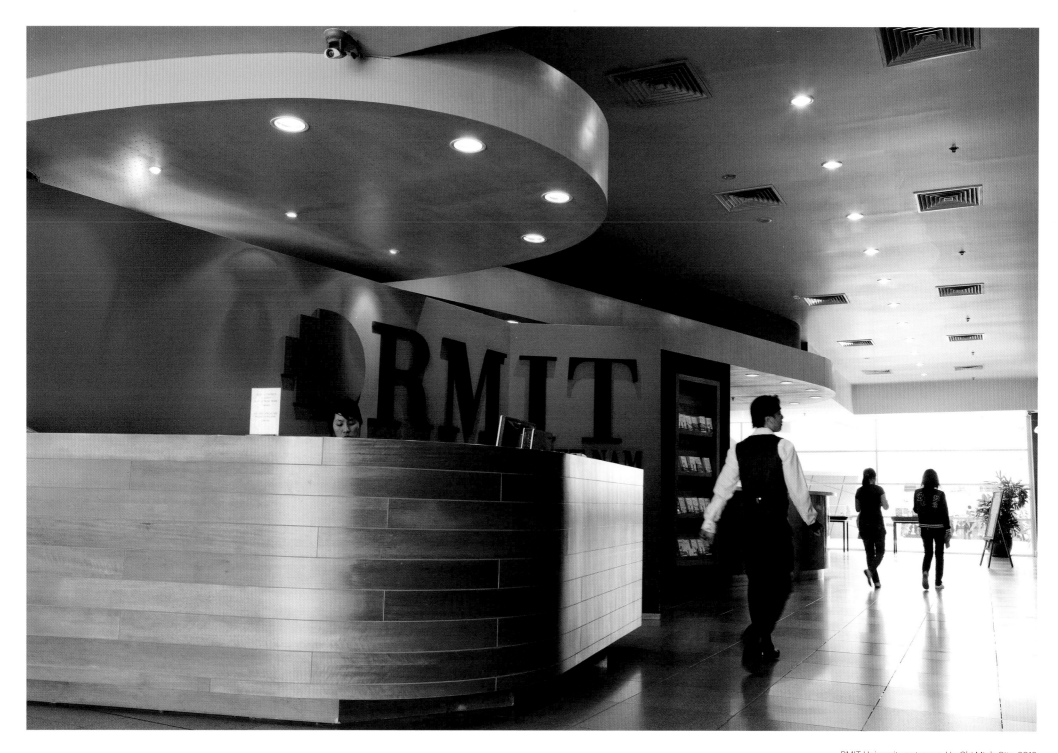

RMIT University entrance, Ho Chi Minh City, 2012

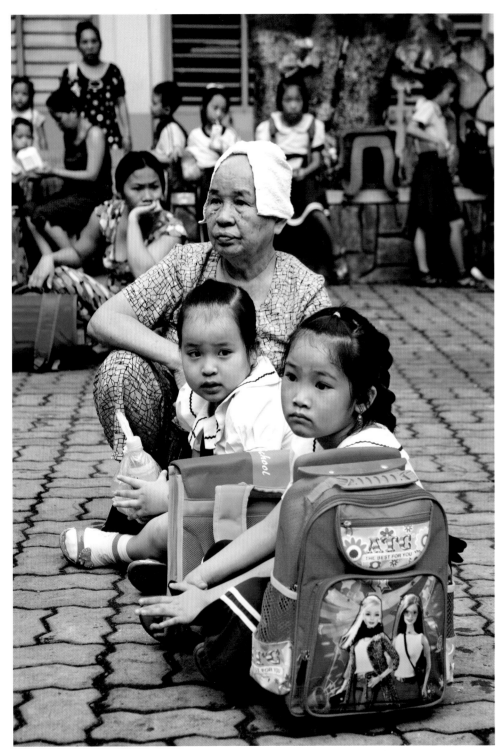

School girls
await class with
grandmother,
Ho Chi Minh
City, 2011

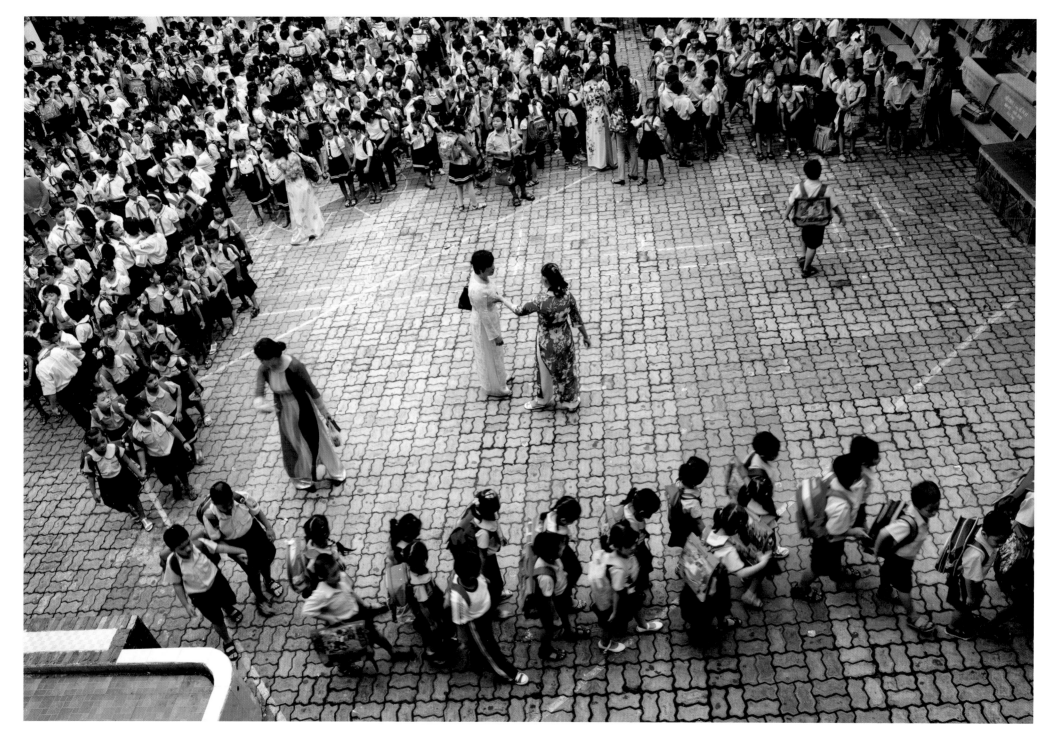

School children line-up for class, Ho Chi Minh City, 2011

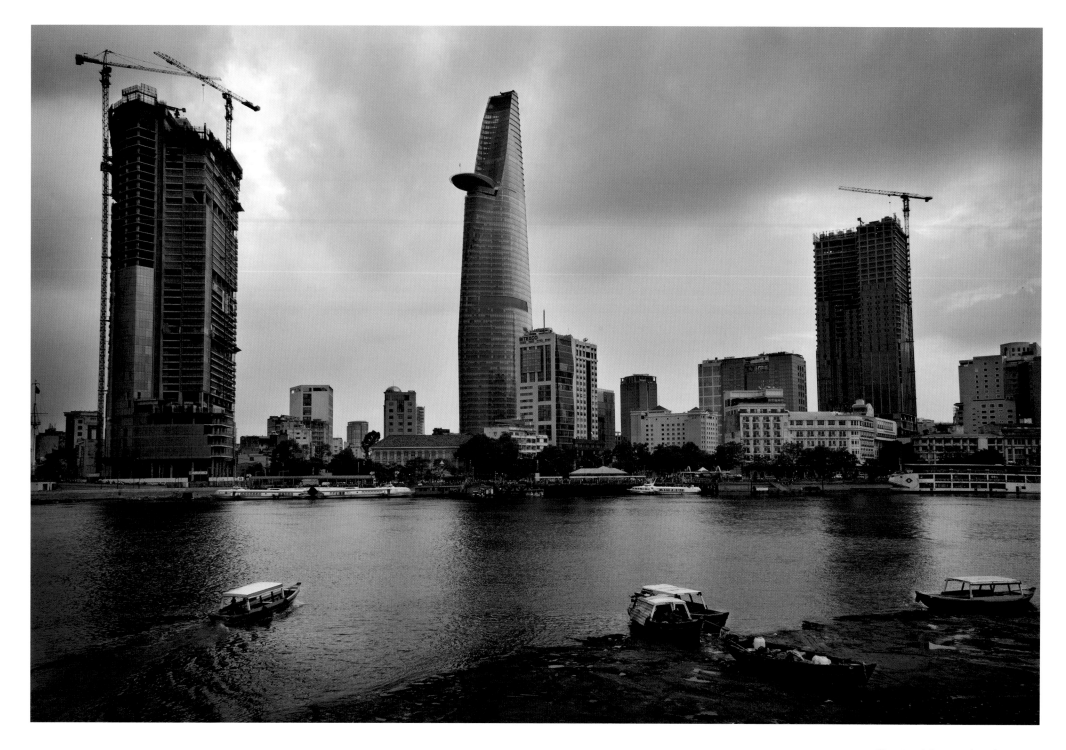

Changing skyline, Ho Chi Minh City, 2011

Robert Dodge

Robert Dodge is a commercial, editorial and fine arts photographer and writer with more than 30 years of experience in journalism and public relations. His work includes portraits, landscapes, and iconic Washington venues, as well as wedding, travel, and corporate and advertising imagery.

While photography has been a part of Dodge's life since age 14, he spent more than three decades as a newspaper writer and editor. In 2006, he left *The Dallas Morning News*, where he had been a Washington correspondent for nearly 25 years, to work in media relations for a major industry trade association. Several years later, he launched an independent business as a writer and photographer.

In 2013, images from his *Vietnam 40 Years Later* project won top honors in FotoWeekDC's Uncover/Discover contest. In 2010, an image from the project won honorable mention in the Santa Fe Workshop's LIGHT contest. The Dallas Press Club honored Dodge for his *Dallas Life Magazine* story *Mr. Bentsen and the President*, which chronicled the close relationship between Treasury Secretary Lloyd Bentsen and President Bill Clinton. In 1982, he was a key member of a team of *Dallas News* journalists who were Pulitzer Prize finalists for spot-news reporting on the bankruptcy of Braniff International Airways.

Dodge was president of the National Lesbian and Gay Journalists Association, 1999-2002, and has served on the Accrediting Council on Education in Journalism and Mass Communications, the academic and industry group that awards accreditation to journalism colleges.

Dodge lives in Washington, D.C., with his two cats, Winston and Tittles, who both enjoy boiled shrimp and a good belly rub. *Vietnam 40 Years Later* is his first book.

Andrew Lam

Andrew Lam is a writer and editor with the Pacific News Service, a short story writer and book author.

Born in Vietnam, Lam came to the U.S. in 1975, when he was 11 years old. He was featured in the documentary *My Journey Home*, which aired in 2004 on PBS, and for which a film crew followed him back to his homeland.

His book, *Perfume Dreams: Reflections on the Vietnamese Diaspora* won the PEN American Beyond Margins Award in 2006, and was short-listed for the Asian American Literature Award. Lam's *East Eats West: Writing in Two Hemispheres*, was listed as a Top Ten Indies Books by Shelf Unbound Magazine. His latest book, *Birds of Paradise Lost,* is his first collection of short stories.

Lam's essays have appeared in dozens of newspapers across the country, including *The New York Times, The Los Angeles Times,* the *San Francisco Chronicle, The Baltimore Sun, The Atlanta Journal,* and the *Chicago Tribune.* He has also written essays for magazines like *Mother Jones, The Nation, San Francisco Focus, Proult Journal, In Context, Utne Reader, California Magazine* and many others. He has been a commentator on National Public Radio's *All Things Considered.* And Lam co-founded New America Media, an association of more than 3,000 ethnic media in America.

Lam's awards include the Society of Professional Journalists Outstanding Young Journalist Award (1993) and Best Commentator in 2004, The Media Alliance Meritorious awards (1994), The World Affairs Council's Excellence in International Journalism Award (1992), the Rockefeller Fellowship in UCLA (1992), and the Asian American Journalists Association National Award (1993; 1995). He was honored and profiled on KQED television in May 1996 during Asian American heritage month. In 2008, he won the Literary Death Match West Coast competition.

He was a John S. Knight Fellow at Stanford University in 2001-2002, studying journalism. He has lectured widely at universities and institutions including Harvard, Yale, Brown, UCLA, USF, UC Berkeley, the University of Hawaii, the College of William and Mary, Hong Kong, and Loyola University. Lam has a Master in Fine Arts from San Francisco State University in creative writing, and a BA in biochemistry from UC Berkeley.

DEDICATION
To my parents, Richard and Frances Dodge, and my sister, Lauren Dodge, for their love and encouragement

ACKNOWLEDGMENTS
Many people have contributed to this book, either by lending their own creative talents or through the love and support they extended. In some cases it was both.

Some key individuals in this project:

Ly Hoang Long, Dalat, Vietnam
Early in my travels to Vietnam. I stumbled across Long's website. I was impressed with his work and admired the way he captured both the essence of place and the lives of ordinary Vietnamese people. I was headed to Dalat, and emailed Long with a request to meet him at his studio. He invited me to his small downtown space, and after a coffee he suggested we go shooting together. An afternoon of photography turned into two days, and a friendship was born.

During the eight years I worked on this book, Long frequently accompanied me throughout Vietnam, working as my guide, translator, and fixer. This book would not have been possible without his extensive knowledge of his country, a knack for getting locals to cooperate, and an appreciation of my goals. In fact, he played a role in encouraging me to open my eyes to photographing a broader range of subjects, helping me expand my portfolio beyond a collection of rural and urban landscapes.

I will always be grateful for his talents and friendship.

Khoa Tran, Ho Chi Minh City, Vietnam
A talented commercial photographer and videographer based in Ho Chi Minh City, Khoa also accompanied me on some lengthy shooting trips. His network of contacts in Ho Chi Minh City were invaluable, his sense of humor made traveling fun, and his work in shooting video for the trailer and promotions of this book are greatly appreciated.

Sam Abell, Charlottesville, Va.
About midway through my project, I had the privilege of doing a mentorship with Sam under the auspices of the Santa Fe Workshops. Sam, who made his career at the National Geographic, is one of the greatest living masters of photography. His tireless and insightful critiques of my work made me a better photographer and had a demonstrable effect on this project.

Greg Gorman, Los Angeles
Another contemporary master of photography, Greg is an influence apparent in my portrait work here. I completed two workshops with Greg, including one at his famed studio in Mendocino, Calif, where I honed my portrait-photography skills and enjoyed some spectacular wine from his private stock. His support was critical when it came time to publish my project.

I also deeply appreciate: My best friend, David Spencer, for his encouragement and constant support; Michael Taylor, friend and confidant, for always being there with a smile and plenty of encouragement; Rex Ordiales, Phil Whalen and Jerry Zremski for their numerous print acquisitions and taking care of my cats during my lengthy overseas shooting trips; Dat Dang, my fitness trainer and friend, for making it possible for me to sprint across the finish line; Bob Witeck, principal of Witeck Communications, for his friendship, bright mind, and candid assessments of my best and worst ideas; Tin Le Nguyen, Duc Huy Ngo Nguyen, and Long T. Nguyen, for sharing their expert country knowledge, serving as skilled guides, and remaining loyal friends; photographer Linde Waidhofer and her husband, technical wizard and author Lito Tejada-Flores, for giving me a valuable jump-start into digital photography; Duy Tran for his generous video contributions; and Trey Graham for his long-term friendship and sharp editing.

ROBERT DODGE VIETNAM 40 YEARS LATER

© Damiani 2013
© Photographs and text, Robert Dodge
© Text, Andrew Lam

Graphic Design Nick Vogelson & Mike Nguyen

DAMIANI

Bologna, Italy
info@damianieditore.com
www.damianieditore.com

Printed in December 2013 by Grafiche Damiani, Bologna, Italy.

ISBN 978-88-6208-325-6